M

MW01235790

MIKE'S CORNER

Daunting Literary Snippets
from Phish's Bassist

Mike Gordon

with illustrations by

Mike Gordon and Priscilla Foster

———————————

A Bulfinch Press Book

Little, Brown and Company
Boston • New York • Toronto • London

Text copyright © 1997 by Michael Gordon
Illustrations copyright © 1997 by Michael Gordon and Priscilla Foster

All rights reserved. No part of this book may be reproduced in any form
or by any electronic or mechanical means, including information storage and retrieval
systems, without permission in writing from the publisher,
except by a reviewer who may quote brief passages in a review.

FIRST EDITION

Library of Congress Cataloging-in-Publication Data

Gordon, Mike.
 Mike's corner / by Mike Gordon ; with illustrations by
Mike Gordon and Priscilla Foster. – 1st ed.
 p. cm.
 "A Bulfinch Press book."
 ISBN 0-8212-2389-5
 I. Title.
PS3557.06696M5 1997
813' .54 – dc21 96-48322

Bulfinch Press is an imprint and trademark of Little, Brown and Company (Inc.)
Published simultaneously in Canada by Little, Brown & Company (Canada) Limited

PRINTED IN THE UNITED STATES OF AMERICA

In memory of Nanny,
who loved my adverbs,
and who encouraged my writing
despite its
confudes of dialect

Contents

INTRODUCTION

THERE I SAT IN ENGINEERING CLASS, listening to my teacher say things like, "We apply the minority carrier diffusion equations to a steady state, forward based pn-junction in the depletion region, considering the carrier concentrations and charge distribution," which is very important information to me. Information which broadened me as a person. I was feeling so broad that I grabbed my little blue assignment notebook and penned some trash. Actually, my first stories were for Mr. Hooper's high school English class. He gave me a check if I had written something, and he didn't care what. He didn't read it. So thanks to Mr. Hooper, who encouraged my writing despite its confudes of dialect.

JOHNALD AND THE AMROPE

A S FAR AS TYKES GO, Johnald was a wee bit irregular. For one thing, he had an Amrope coming out of his head. You may be wondering, "What is an Amrope?" I won't piss on you for wondering that. Actually, it's like an antenna, but it's got some mold on it. It's not something you buy at a store; maybe you do buy it in a store.

"Johnald?" yelled Mrs. Amrope.

"I'm combing my hair, leave me alone."

"Oh, well you're not going to comb that hair in the kitchen!"

"I need to do it here because the Amrope gets greasy, and the only way I clean it is with some of your cooking tools."

"Johnald, don't use those tools for that. It's sick. By the way, I got us fair tickets, let's go to it. Now." And they were off. Soon they found themselves on a merry-go-round.

"Hey! You! What's that moldy antenna on your head?"

"It's my Amrope, don't make fun of me." At the fair, later that day, someone else also made fun. The same thing happened at school.

"No, you have to carry the denominator and place it behind the other number," said Ms. Baby, "and take that thing off your head, Johnald, before I call principal Ope."

"I can't, it's built in."

"Johnald, I want you out; now."

Later in life the same problems plagued Johnald, even at Thanksgiving dinners.

"Could you pass the turkey?"

"I don't think so."

"I am Johnald, Johnald with the Amrope, and I feel I deserve some turkey."

"We're kidding you, Johnald. You've aged, but I still kid you, and I still wonder about your moldy antenna."

"Who are you?" asked Johnald.

"I'm Uncle ATTLINGBURGER."

"You never met Uncle ATTLINGBURGER?" asked Mrs. Amrope.

"Can't say I have," returned Johnald, melancholifully.

"Well, this has been a lesson to all of us," said Uncle A. "I think we have all learned, the hard way, I might add, that it's not appropriate to make fun of someone's moldy antenna."

"Well, it seems that all's well that ends well," added Mrs. Amrope.

"I'm happy," exclaimed Johnald.

"Good," they all said in unison. And for the rest of their lives the whole family talked in unison only. It sounded odd as hell, but if one Amrope person talked, they all did.

"Well, I guess we're doing fine," they all said in unison at a future Thanksgiving dinner.

And thus ends a bittersweet tale of woe. One guy, born with an atrocity, finds peace. The whole family, even Ms. Baby, and ol' Uncle ATTLINGBURGER, they found peace too. What's more, it seems they learned a lesson. And it seems that lesson is a lesson that they will never forget. And it seems that if they do forget, that they won't forget for long. And it seems that if they do forget for long, then at

least one of them, like maybe Uncle ATTLINGBURGER, won't forget. It seems that at least he would remember. If no one else remembers, than Ms. Baby could, she's got a swift mind. It's a remembering mind, a mind that, as they say, doesn't forget. And it makes sense that it wouldn't forget. It's just a mind, it remembers, that's what it's for. And even if it forgot, there's other organs that, in some ways, have memory. Like now they say that a fist has memory. The moral here is that various parts of the body can also have memory, and I don't mean just the fist. I mean, really lots of stuff has memory. Different kinds of stuff can have memory. Stuff remembers. It remembers stuff. That's what it's for: remembering. Things are for something, and it all goes to show that somethings are for remembering, not just anything. Things aren't just for anything. Things are for something. A thing is for a thing. It is a thing. Things are themselves. They equal one another. Thing=thing.

THE PARTY

ONALD GRANDFATHER WENT TO HIS CAR and returned with a map. It was his eleventh birthday party and all of the boys and girls present had pooped on the floor. He opened the map to its Arkansas side and scooped all the poop onto it and then poured the poop carefully into a bucket of worms and mashed potatoes.

"Thank God that's over with," thought the young driver as he rejoined his pooper friends at the birthday cake table.

"Make a wish and then blow out the candles until you've canceled each flame," instructed Donald's mother. After blowing out the eleven candles and the twelfth good-luck candle, Donald went out to his car to check the oil. Things under the hood looked okay, except one of the battery terminals. It looked horrible, as if someone had banged on it softly with a Phillips screwdriver. He dropped the hood, allowing it to slam down, and returned to the dining room of his parents' green Victorian home.

Martha Lester politely lifted her plastic fork and withdrew a small bite from her wedge of cake. She placed it carefully on

her tongue and then pulled her tongue back so that the cake touched the chunk of flesh which dangled loosely in her throat. If she hadn't swallowed right then, she would have gagged and spewed, but she did, and she said, "A fine cake you've made, Mrs. Grandfather."

"Actually, it's store-bought," whispered Donald's mom. Martha's smile turned to a frown. She arose from her chair and then squatted and pooped.

"Shall we go for a drive?" suggested Berry Weather, the oldest man in the room. He had just celebrated his twelfth birthday.

"No terminals," remarked Donald.

"Get out of here, you batworm," said Berry Weather.

"No, seriously … no terminal."

"Batworm."

"If you'd all like to stay for dinner, I'm fixing heaps of mashed potatoes," added Mrs. Grandfather.

"I'll fix 'em," said Martha.

The only one-year-old present said, "No. I'll fix 'em." Young Misty Small had just started talking that morning. "Seriously, Ma'am, I'll fix 'em. I'll fix 'em with cheese and butter and salt and you'll love 'em."

Just then Henry Grandfather returned from work. He

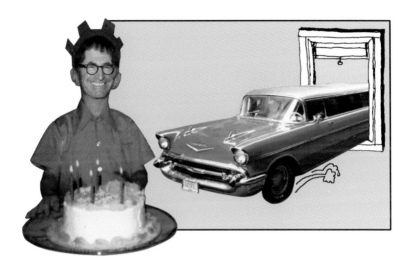

opened the door and exclaimed, "Party's over. I want everyone out. *Now*."

Just then Hobbs Snowman, the gardener, entered and exclaimed, "Quick, I've gotta get some help untangling shrubberies."

Hobbs's mother, Seth, was on the phone with her uncle's client, J. Stitch.

Stitch said, "Hold on," and he cupped his hand on the mouthpiece and told his secretary, Jean Lemon, that she was fired.

Jean got a job on Fifth Ave. working for a man in a pair of jeans he got from the hot-dog man's mother's helper. The helper got a maid who knew Rob Reiner's mentor, Alan Walker, the guy who always quoted his mother's friend. She had a saying, "The longer you sleep, the older your daylight."

And the daylight was getting old back at tableside. Berry Weather had walked over to a shelf with some stereo components. Young Misty Small said, "This song has no tone." So Berry Boy Weather twisted the tone knob.

"Too much tone!" yelled Hobbs Snowman from the garden. But the tone made everyone happy. Even Henry Grandfather sat down to smile and to eat some cake. Young Misty Small offered mashed spuds. Donald Grandfather put spuds and cake together on a spoon and pushed it back.

"I'll remember this birthday," said Donald to his mother, Seth.

"Yes you will," said Seth, "yes you will."

101 PRALINE LANE

A CREATURE NAMED STEVE dabbed a dollop of horseradish into his tall, thin glass of soy milk. He loved the combo.

"If only I weren't such a hideous creature," thought Steve as he sipped the beverage. Just then his phone rang. The office phone was blue. Damnit, it was pink. "Steve's Burglar Alarms." His face reddened as he repeated the worn greeting.

"Yeah, I've got one of your alarms and it's going off and there's no burglars!"

"Not a single burglar?" said the beast. He thought within, "Damnit, the new rigs aren't working. I better just go back to the 8040s."

"No, I tell you, I paid for this thing and it's buzzing and fuzzing and going 'drang drang' and there's no burglars and I'm gonna call the BBB."

"Okay, just tell me your name and the date the unit was installed."

"The name is Dale Chihuly, and this…

Part II

contraption was put in on December twenty-fifth."

"Hmm…December twenty-fifth…Okay, we'll be right there." The creature named Steve was momentarily perplexed. "Chihuly…Chihuly…Oh I know! It's Dale Chihuly, the famous glassblower. What kind of a creature am I, selling an 8060 to a famous glassblower? I should have my tentacles twisted." He reached for the phone and called frat-boy Pete Clam to go and burglarize the home of famous glassblower Dale Chihuly.

Pete Clam sniffled his nose, opened the top-hinged door of his Maserati, and hopped in. It was only three stop signs and a traffic light to Praline Lane, the rue of famous glassblower Dale Chihuly. Pete Clam checked his thick underwater watch. The trip had taken seven minutes. He parked in the driveway at 101 Praline Lane.

Inside Dale's Moroccan/Victorian/Gothic deck house, the blower was blowing the biggest single-flower vase ever created by humankind. A bubble of glass twelve feet in diameter was sticking way out of the furnace and filling the furnace room. Purple streaks laced the otherwise aqua-tinted glass. One wrong move and Chihuly would be covered from head to

toe in a deadly pool of glassy broth, swallowed by his own creation.

Pete Clam covered his head with a stocking, withdrew from his holster a Saturday night special, and kicked open Chihuly's pantry door. He aimed the fancy weapon straight ahead, but to no avail, the pantry was empty.

Through a tube, Dale blew the twelve-foot bubble bigger and bigger. There was barely room to avoid touching the bubble.

Pete Clam kicked his black boots into the kitchen door and aimed his archaic firearm straight ahead. To no avail, the room was empty.

Dale took a deep breath and blew his vase to fourteen feet in diameter. He felt the scorch of molten lava against his right forearm.

Suddenly, Pete Clam kicked in the furnace room door and aimed his medieval deathwand straight ahead, piercing the hot bubble wall and thus popping the vase and covering the room with liquid glass. His lower half frozen into a glassy clump, famous glassblower Dale Chihuly reached for the phone and called the gross-looking creature named Steve. "I guess your burglar alarm worked. There *was* a burglar."

"Good to hear, good to hear. Just call if you have any problems. Bye-bye." That day, as he walked home, many stared at the smelly monster. He had no abnormal features, except that he was a terrible creature. "I'm a horrible creature," he thought.

ZONTICUDDY

JOHN RISZN WAS A NORMAL GUY. Then he wrote *Zonticuddy* and everything changed. For example, now he would be bothered in the street.

"I really liked *Zonticuddy,*" a stranger might say. "What were you thinking? I mean, *Zonticuddy!* It's total." Also, phone bills became easier to pay for. John found that he could write a check without necessarily worrying about bouncing it. *Zonticuddy* was on the best-seller list for ten days, and the after-whip socked a coin in the bank.

It seemed, once again, that even with *Zonticuddy* things were seeming real normal. Then he wrote *College Rimshot* and things redenormalized. It wasn't bad-not-normal, but good-not-normal. Some days still seemed normal, but most were mid to high not-normal. This was all fine except for one

thing. I hate to sound critical, but *College Rimshot* was a bad book. It wasn't about anything. It's like a bunch of words with no denomifiers. Come to think of it, John Riszn is a real bitch. I'm not saying that every book is going to be a *Zonticuddy,* but *College Rimshot* is a crappy book.

THE OBSCENE PHONE CALL

T HE SPOTLESS BLACK TELEPHONE RANG. Mildly startled from her daydream, Margaret Pistachio swiveled from the window to the phone and uplifted the receiver. It was not a call for her, but for Darla Pistachio, the other master class secretary sitting in this too familiar office of Business Systems Ltd. The two Pistachios had no relation to one another.

The phone call was a wrong number.

THE SCOOP

EDITOR ONK HAD NO PATIENCE for slush. His phone rang. "Onk, it's Ben. I've got an idea. Just think: the one life source—the central, big energy source for this whole solar system—is in plain view every day, but we can't look at it—"

"Yeah—it's good, it's good. I'm gonna give McGrim the McDown murder story. I want you to follow up on this sun thing. Get everything you can get. We're talking front page. This is big." Click.

Part II

Later that day, Ben found himself in McCream's Coffee Shop twirling coffee with a double-barreled straw.

"There it is," he thought, "it's the…the source, and we can't look at it. If we do look…oh, how's it going, McCream?"

"Well, you know."

"Yeah. Say, McCream, see that thing out there?"

"What Ben? The salt shaker?"

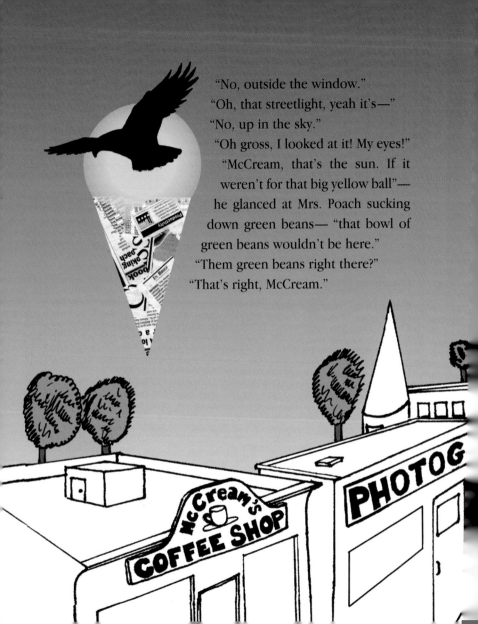

"No, outside the window."

"Oh, that streetlight, yeah it's—"

"No, up in the sky."

"Oh gross, I looked at it! My eyes!"

"McCream, that's the sun. If it weren't for that big yellow ball"— he glanced at Mrs. Poach sucking down green beans— "that bowl of green beans wouldn't be here."

"Them green beans right there?"

"That's right, McCream."

Part III

Evening came like a falcon swooping. Ben fidgeted with his keys, the phone rang from inside, he fidgeted harder. The phone stopped. Once inside, Ben pushed "play" on his answering machine and went to turn up the thermostat.

"Ben, it's Hector Dunk from Badrim Eyeware. Give us a call. Your prescription sunglasses are ready. [beep]"

"Ben, it's [beep]"

"Ben, it's Onk. Forget the sun thing. No one cares. [beep]"

Part IV

Ben called Onk.

"Onk."

"Ben."

"The sun—McCream."

Dunk [beep] bean McCream

"Onk" bean

McDown, McGrim

[beep] shaker sun

A SUCCESS STORY

FITCHIE

FITCHIE IS CONSIDERED by many to be a successful accountant. "Successful?...Me? ...Sure," Artie will sometimes say. Probably, his success is one thing he can count on. "Successful" is a word to describe some people, and Artie Fitchie is one of them. In business circles, Fitchie, when talked about, is often referred to as "...successful..." Though some do not succeed, Artie does. To succeed is to be successful, and Fitchie is both. He didn't ask for success, he didn't not ask for it, he got it with or without asking for it. "Failure" is a far cry from Artie's current condition. Success is a much closer cry. Actually, it's the closest cry. "Success" has a capital "S" only at the beginning of a sentence, and I bet that sentence would include

Artie Fitchie. When given a capital letter in the middle of a sentence, that sentence certainly involves Fitchie. The small-case lettering is a far cry from the appropriate lettering here. Capitals are a closer cry. Some people realized that this thing called Artie Fitchie was gonna make it. Success doesn't come overnight, but in this case, whether or not it came overnight, it came. It came to Artie Fitchie. If a lot of people succeed, that's one thing, and if Artie Fitchie succeeded, that's a true thing. And he did; and it is.

INFANTRY

FOUR ANGRY BABIES headed straight for the Hennison building. These babies meant business. Three of the babies marched up to the rotating door and went into the spacious lobby of the skyscraper. The fourth baby was left behind, due to his being stuck between the rotating glass door and the glass surrounding it.

The three angry babies boarded the jet elevator and shot upward to floor ninety. (The babies would not have gotten off on floor ninety if they did not mean business.) As if they didn't know what fear was, our newly born powerhouses barged right into the forbidden office of Arthur Doubletrouble Hennison.

Arthur's secretary, Alfred Buggyboo, immediately stood on his tippytoes and demanded, "What do you want, you terrible babies?"

The babies ignored Buggyboo's question, walked up to Hennison's door, ripped it off its hinges, and hurled it through a window, killing four Swedish exchange students on ground level.

Now, Arthur Hennison was an old man, young in years. He wore a blue and gold cone-shaped wizard's hat. He was not sitting behind his desk, in fact he was lying facedown on the desk, dead.

The terrible toddlers were stunned at first. They had never seen a dead man before. In fact they had never even been dead before. One baby said, "Googolplex."

Part II: Did Buggyboo Do It?

No.

Part III: The Arrival of Winchester

Shortly after the three evil babies discovered Arthur Hennison's corroding carcass, Buggyboo entered the room. After his initial shock, he sat at Hennison's desk and began to make several phone calls to randomly selected male "Caucasians."

It was at this time that Arthur's long-lost black cat, Winchester, wandered in the door to the office (actually the cat's name is Horace, but we shall call him Winchester for simplicity). Buggyboo dropped the phone receiver in excite-

ment when he saw Winchester. He opened his arms wide and ran across the room yelling, "Horace...oh Horace."

Winchester ran on her hind paws toward the maniac secretary, yelling, "Buggyboo...oh Buggyboo." The two embraced.

Part IV: The Missing Link

Have the three satanic infants forgotten their fourth partner, who is still trapped ninety floors below?

Yup.

Part V: The Murder Is Solved, the Babies Get What They Want, Winchester Gets Tied in with the Rest of the Story, and Buggyboo Becomes Rich and Famous

LUNCH BREAK

THERE WAS LITTLE TIME FOR LUNCH in Theo's busy day. Fridays, Lemm the chef went to "escargot school," and the replacement chef often took countless extra minutes to accurately prepare the house specialties. Theo wondered why he had ordered something so elaborate anyway. He wondered why he had left the pile of work on his desk and the people waiting patiently outside of his office for a "transition meeting."

"No, it's okay. I'm hungry. It's lunchtime. Most people eat lunch." In the middle of his oak-veneered lunch table there was an ornamental square indentation, and that is exactly where Theo had chosen to plant his glass of water. He coveted it as his only current consumable. The waitress had been gone for at least eight minutes, and it seemed she was gone for good. He was pondering her absence and the cold blandness of the icy water when suddenly church bells rang outside in the square. This indicated the coming of noontime, and it would still be another two and a half minutes before the "strange things" started

happening. When the reverberation from the chiming finally decayed to nothingness, Theo rattled his glass without taking a sip. A stirring had been needed to thwart off the returning silence. Feeling a gust from behind, he turned, expecting the waitress, but alas it was a gust only. From one quadrant of his brain, a signal was sent out to the other regions that it was time to continue worrying about the "transition meeting" people waiting, and so on, and somehow, remarkably, the courier of this internal message didn't deliver. For once, Theo just sat there. Nothing else.

That was when the strange things started to happen. He looked at his water as if to take a sip, but he felt quenched without drinking it. Of course he wasn't particularly thirsty, but he could feel the moisture in his mouth as if he had taken a sip. It was a strange sensation, actually a familiar sensation, but slightly out of context. While contemplating what had just happened, he looked at the peculiar glass and saw that the meniscus was about a hair lower than it had been—as if the water had been depleted by a sip's-worth. Then, to top it all off, he realized, undoubtedly, that his waitress was God. He almost couldn't believe it. But it all made sense now. The evidence had clearly pointed in that direction since the moment that he walked in the restaurant. He had just been

too closed to be able to see the obvious.

The waitress, Her Holiness, must have vanished or taken a different form. That, in fact, is why lunch hadn't yet arrived. Oh no . . . all that stuff to be done in the office and lunch is delayed. He assessed the situation and realized that God would never return. Yes, he was positive of that. She was gone. A moment later, she returned though. She didn't have lunch yet, but She did have a glass of water. She said, "Oh . . . where did you get that water? I was just bringing you some."

REGARDING FITCHIE

ARTIE FITCHIE, we have learned, is successful. He is the beacon of success. There was a curious woman in Iowa who wrote to us and asked: "…regarding Fitchie…with all this success, is he happy?" It's quite possible in this era that a person is successful on all accounts, but inside he's sad: Nope. Artie Fitchie is happy. In fact, he's beaming. The guy is beaming in excitement. BEAM! Even after viewing a sad movie, Fitchie feels happy to have seen it. In fact, all of Fitchie's "problems" are diagnosed in his head as opportunities to practice patience and thus they are sources of happiness.

It could be argued that an equal amount of sadness is necessary for a person to recognize and enjoy his happiness: Nope. Fitchie only experiences the happy side of the coin, and he appreciates that coin. That coin is Artie Fitchie, and

both sides are happy. Inasmuch as a coin is a "yin and yang," Fitchie is happy with yin and with yang. He would be happy with sadness or problems, but he has neither. Fitchie noticed that one could say "happyin" or "happyang," and noticing that made Artie Fitchie ecstatic with joy.

THE JOB

FRANZ RICH WORKED FOR A STUFFING CORP. He stuffed mac with cheese, cheese with mac, et cetera. As for working for a different Corp., he thought, "No, I'll stay put."

One day his leader, Rex Bulb, said, "You stuff well," and this made Franz smile. In fact, it made him stuff more. He stuffed his butt out. One day a different Corp. called and offered to "lay their bets on the table."

"No, I'll stay put," said stuffer Franz Rich. Then he went back to work as if that black little utility phone had never rung. Rex Bulb came by because of "lay their bets on the table."

Franz said, "Rex, as far as people like you go, you're a jewel." This made Rex smile. He smiled not only in the Corp. but later outside it. He even thought, "I'm outside it and I'm smiling."

One day the black phone rang. It was a different Corp. Rex said, "Franz, it's for you." Franz looked at Rex and then at the phone and they both smiled. Later that day they smiled outside it.

Rex stuffed sometimes, if Franz needed help, but hell, he never had needed help. "Not needing help" made these guys smile outside it.

One day the sticky black phone rang silly. They picked it and it was a different Corp. This made Franz and Rex Bulb smile. They smiled outside it.

Once Franz did need help! Rex didn't stuff. Phone rang. No one smiled. It was a different Corp. Rex Bulb cracked a smile. Later that day Franz smiled outside it.

FAT WAVES

AGACE WAS A FORERUNNER ON THE BASS. He liked to "vibrate people." "What good is that?" spewed a man at the coin-op laundromat.

"Well, I've discovered two frequencies," revoked Agace, raising his lanky shoulder blades and gently scuffing his maroon sweater in a way not typical of bass players, "340 Hz and 39 Hz. By bending a string and holding it, I can achieve one of these frequencies." He hopped on a Speed Queen dryer, accidentally kicking the side too loud with his black army boot. "340 causes dismay, whereas 39 pushes people into ethereal flotation. It only takes a split second."

That night, the man in the laundromat chanced to be transversing the sidewalk in front of "Loon-Club," where

Agace accompanied local favorites "Monzy-Dart-Witch." The band covered Hall and Oates and Mingus. Period. Except one original that the fat drummer had penned called "Tulips Are So Pretty, Oh, Oh, Oh, Pretty." This song called for a bass solo at bar ninety, and sure enough a note was chosen by the straight-haired goon of a bass jockey: 39 Hz.

Flotation started in the back, at the end of the bar. A man pushed aside three separately flasked samples of Rolling Rock backwash as he floated to the ceiling. Conversely, the laundry goon never did step in the door of the club. So…no flotation for that goon!

HANDICAP

TERP WAS SAID TO BE A "bilingual guy in a trilingual land." Of course he lost the will to learn after the "horse" incident. Years ago, five men on horses aimed their rifles at Terp and his brother, Connd. Terp said, "I can take these guys."

"Terp!" said Connd as Terp reached to crack a blow. It was too late. Five bullets pierced and wounded. Needless to say, there would be no time to learn that "third" language.

Now it's 1985 and no one speaks of the "horse" incident. Terp is practicing medicine and a patient awaits patiently. Terp's nurse, Connd (no relation to Terp's brother), goes to the waiting room and announces, "Terp will see you now." A lanky young short giraffe of an old buffalo hobbles into the examination room.

"Just take off your shirt, shoes, and that Viking cone you've got on."

"The buffalo unlaces his loafers and carefully removes his shirt and Viking cone," narrates Connd from the hallway. Terp shuts the door and apologizes for the uncalled-for playfulness of his nurse.

"So what seems to be the problem?"

"It's this rash. Also yesterday I got a migraine at the races. I had four bucks on 'Skippin' Wilson' and I looked at the clock and the harfshump harfshump!"

."HARFSHUMP?!" exclaims Terp. "What is that?" He realizes that it must be something from that "third" language. "Oh no. OH NO! I don't know that language! Get the fart out of my office, you buffalo."

So once again a patient is lost because Terp is a "bilingual guy in a trilingual land."

Part II

Later that day, Terp shops for "groceries." The same thing happens. Trilingual/Bilingual…same thing.

Finally he gets a three-way dictionary. Doesn't help. Trilingual/Bilingual.

So it's the next day, right, and Terp gets another patient and, check this, it's one of the five horsemen, and then, right, the guy says, "harfshump," so Terp thinks, "Oh no, like, Bilingual/Trilingual," and they're standing right there and a guy walks in, right, and it's Connd, Terp's brother, coming in because he broke his eye, and so the two Connds stand there for like ten minutes and talk about having the same name, right, and so Terp makes this joke, he goes, "Will the real Connd please stand up?" and his brother goes, "I'll give you the Connd if you give me a patch," right, and so they patch up his eye and the buffalo comes back and goes "harfshump" and shit, and it's like, "bilingual/trilingual."

MEAT

IWENT TO MICKY-DEE'S and bought a hamburger. I then
brought it home and soaked it in detergent. Finally the
guck was removed from it. Then I picked each little glob of
hamburger off and began to assemble a cow. When I finished,
it was a simple matter of buying a grazing platform.

I went to John's Cheese-Dog and bought a dog. I sucked
off the cheese and then began to pick off tiny globules of hot
dog substance. When I was done I used the globules to
reassemble two mice.

DEEM TEAM

"**D**EEM TEAM. MAY I HELP YOU?"

"Sure, we'd like a deem."

"You can't have one."

"Can too."

"Not."

"Too."

"Okay, we'll send you a deem." Chuck Razzle liked to deem, but he did not like telemarketing.

"Why telemarket if you don't like telemarketing?" asked Frimoje Frimmen, Chuck's favorite pal-chum.

"Well...because deem!"

"Dingles," rang the phone.

"Deem Team. May I help you?"

"Yeah, I'll take your damn deem."

"Say I've got no deem."

"You've got deem."

"Not."

"Too."

"Say, could you call back? I hear something broiling."

Chuck smashed the receiver down and ran to the deem room. Nope, nothing broiling.

"Fringles," rang the phone.

"Deem Team."

"Yeah, I'll take a deem."

"Yeah, you know where you can deem."

"Listen, I said I'll take a deem."

"Say I say you're not eligible."

"Say you say I am."

"Okay, we'll send you some deem. Goodbye. Hey Frimoje, do you hear something broiling? Like some kale?"

"No, Chuck. Say, how's deem?"

"Oh…" Just then the phone rang. "Deem Team."

"Say I want a deem."

"Say get out."

"Say deem."

"Say get."

"Deem."

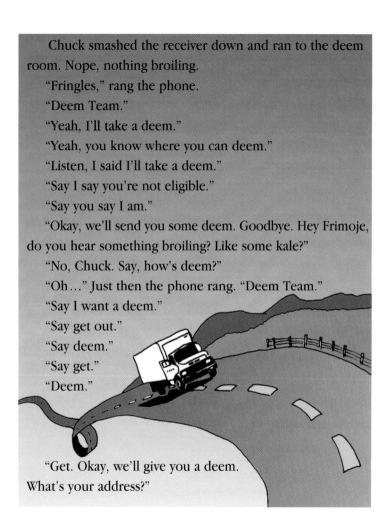

"Get. Okay, we'll give you a deem. What's your address?"

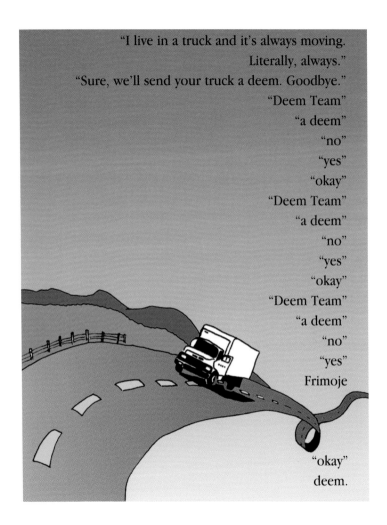

"I live in a truck and it's always moving.
Literally, always."
"Sure, we'll send your truck a deem. Goodbye."
"Deem Team"
"a deem"
"no"
"yes"
"okay"
"Deem Team"
"a deem"
"no"
"yes"
"okay"
"Deem Team"
"a deem"
"no"
"yes"
Frimoje

"okay"
deem.

THE PROBLEM

IT WAS A SMELL PROBLEM that plagued Farny Moniasis. Farny, the youngest member of the well-respected Parsleyfield Church choir, couldn't smell. It could have been worse. Consider, for example, the inconveniences of blindness. And as with most things, there were exceptions. Farny could smell certain foods: bananas, beans, beefsteak, beer, bread, butter, cabbage, cake, candy, cheese, cherries, chicken, chocolate, coffee, cream, dates, eggs, fish, grapes, lamb, lemons, lettuce, lobster, meat, milk, oranges, oysters, peaches, pears, pineapples, plums, pork, potatoes, rice, shrimp, soda water, soup, string beans, tomatoes, turnips, veal, vegetables, wine, and zig juice.

Farny was actually pretty sexy for someone so lanky and introverted. At least that's what Jamie thought, the doctor who prescribed Farny's smelling-aid. Of course, the diagnosis was undertaken in a purely professional manner. Jamie brought out trays of things to see if Farny could smell them. Farny couldn't smell any of these putrid morsels. Being an only child, and a swimmer, Farny was hoping to be helped by

the smelling-aid gadget to smell underwater things, like an old flipper that was somewhere at the bottom of the Moniasis family pool. The issue remained unresolved, since the good doctor placed no morsel of flipper on the tray. Farny sighed. The real problem was that the nose on the face of this Parsleyfield head could not smell anything—not a single thing.

So the smelling-aid was brought in. Ironically enough, Farny could smell the smelling-aid, and it really stunk. It was just terribly rotten smelling, like mildew and the kind of fungus that would grow on the rotting carcass of a lamb. Despite that, it was administered to the center of Farny's nose. It hurt, yes, oh yeah, it hurt. But after twelve minutes, all kinds of odors were smellable, beyond the terrible stench of the aid: Jamie's doorknob, the frames of several doctor certificates, and even a paperweight. Of course, Farny couldn't smell this stuff. No one could.

So the receptionist was paid 1240, and believe me, these weren't dollars and cents, this was money. And the swimming improved, and the choir singing improved, and the flipper was found. Farny even got married. Five years later, upon reflecting, Farny thought, "I'm pretty lucky for someone of my gender. I can't smell, but at least I don't have to deal with the

inconveniences of blindness." Over the years, and believe me we're not talking about months but years here, Farny developed a similar problem. This time it was a different sense that was impaired. It was the sixth sense: ESP. Farny had none of it. I mean some people have a tiny bit of it, a little intuition guided by ESP. Farny hadn't a trace of it. And, of course, you can't just go and get an ESP-aid. What do you think this is, some sort of fantasy world? Well, the funny thing is, Farny did get an ESP-aid, and what's more, it worked. Traces of ESP were demonstrated from time to time. Not a lot of ESP—but just enough—a normal amount. Of course "normal" for Farny Moniasis was no-ESP. The ESP-aid even seemed to help the smelling-aid. Not much—maybe a little. Problem was that Farny still could never smell anything. And another problem: experiences of ESP were far too few for such a good-headed woman. And another problem: experiences could never smell anything.

7

JENNY SIT WAS STROKING the "x" key too many times in her seventh grade typing class. It's because her attention drifted. Mr. Sit is a philosophy professor at Darkmount, but the Sits seldom pondered abstract issues at the dinner table. It was on its own accord that Jenny's mind found itself asking about "meaning." What does it mean? What makes me tick? Do I tick? Is it romance? Is it movies and novels? xxxx Do they provide direction, or are they quick fixes? Is it music? Is it just this beige typewriter, with its missing $\boxed{\begin{smallmatrix}\&\\7\end{smallmatrix}}$ key? Will I find out later? xxxx Should I ask Dad?

She ended up asking him at the dinner table, sixteen years later. How do I know that my life has any meaning? I love to do things, and I love certain people, but I don't understand movies. They strike nerves. I feel like I've missed the boat, not to have done what the heroes in movies have done.

He bit his buttered roll and answered, fifty-eight years later. He was 116 years old. They sat at his glass table, face-to-face. This time, she had cooked for him. It was a plain meal, but the china was elegant and priceless. "I figured out the

meaning thing," he said, "the raison d'être issue." Jenny Sit sat and stared. "It's your beige typewriter with its missing <u>& 7</u> key." (xxxx)

TYPE O

RANDY ENCOMPTM PLACED A DISH of calamari and peach fungus on the corner of his desk, right next to his computer screen. He knew it was time to finish his weekly column, "Food for Your Stomach." Editor Rake-head was stubborn about deadlines and the deadline was in one hour. Still, Randy liked to procrastinate. He shoved a glop of lunch into his mouth and opened up today's paper to the horoscope section. Scanning his eyes to the Gemini entry, he read, "Don't worry about small mistakes, or you will dye."

"Dye?" he asked out loud. He folded the paper and positioned it on his lunch bowl. Withdrawing an ink implement from his canister, the famous food critic began to write his little report on the recent wave of fish-mixed-with-fruit dishes.

"The catch of the day isn't just swimming upstream but rolling down tree."

"That's dumb," he thought.

"Had to taste the stuff a few times before the feeling coalesced, but now I'm riding the wave, and it seems I've caught the bait, and…

"This is stupid. Maybe I better see what I wrote last week." Randy realized that he had never even looked at last Tuesday's paper. At the circulation desk, Sondra was more than bitchy.

"Here you go, you craphead!" she said. He shrugged, and then he shrugged again. Returning to his desk, he sat down and reshrugged. Opening to the Living section, he spotted his article, "Bubblegum in Clam Recipes—Not Just a Fad." He read the first few lines. Suddenly Randy Encomptm froze in his seat.

"Oh no. This isn't right." He read the line several times to double check.

"Bottleneck clams seem to be the cream of the crap."

"That's not right. That's a typo. Oh my God." He reshrugged. Slightly frustrated, Randy swallowed another glop from the bowl under today's paper and wrote his blurb.

"God, people must think I'm a doofus," thought the shrugger while pulling into his red ranch driveway at the end of the day. "I guess I'll see if Dandy wants to help me with some yard work while the sun is still out." His wife, Dandy, was a small woman. Her head was huge.

"Hi, Honey," she said. "I've been thinking about painting the mailbox. Wanna help?" So thus they went to the mailbox

and applied a pinkish undercoat. Then he painted the pole while she painted their names over the drying pink paint. After eleven minutes he looked up to admire his wife's calligraphy.

"Mr. and Mrs. Randy and Dandy Doofus,"

"Honey! What are you doing?"

"Oh, I'm sorry, I must have been thinking about something else."

"But why 'Doofus'?" Randy returned to the house and picked up the *New York Times* on his leg table. He had dreamed of writing for a prestigious paper, but now he knew he never woode. The big headline on page two was, "Bush promises to lower Taxis."

"I wonder what this demeanor. Is it a scroope?" asked Mr. Encopmtm of himself. "I think I'll ask Dandy if she's wants to go 'fore ride to cotton candy store headlights."

"Hey Dandy."

"Yeah Panda."

"Let's gommo heado cott-bed."

"Oh here-ye, I'll go."

They rose above too a flower shop fourth, then to candy stump. Randy Dandy Encomtomp drive's to her's down to candy stump. Editor Rake-head is a doofus. He's the real

doofus. "Maybe I am a doofus," said Randy to his own mind. "Maybe Sondra doofus???? Maybe pinkish undercoat is say doofus."

"Honey sometimes you make me feel like a hundred bucks, but now I make you feel like about a hundred bucks." "He" said. Maybe peach squid is the doofus." Ever think of that?

How bout a doofus!!!!!! doofus doofus doofus doofus. You mayk' me feel like a ten spot. "Food for you stom-ache." Doofus is a Doofus. I know I'm a doofus. Doofus. Scroope. Dandy. Shrugged. Clam Crap Doofus. Doofus Doofus. Bush Panda. Peach crap." Just then Randy Encomptm hit a paint truck and got all covered with a pinkish dye.

CANINE THERAPY

DEAN COYOTE SAT down in his therapist's office. Therapist Tazzle was ultra calm. He seldom flinched. Coyote was goose-like and rambunctious like a tense eel. The two commenced.

"Tazzle, I'm frazzled," exclaimed Coyote. "I just bought a coy dog and the animal knew my wife before her ex-husband knew me. You see the dog was not just a dog."

"What are you getting at, Coyote?"

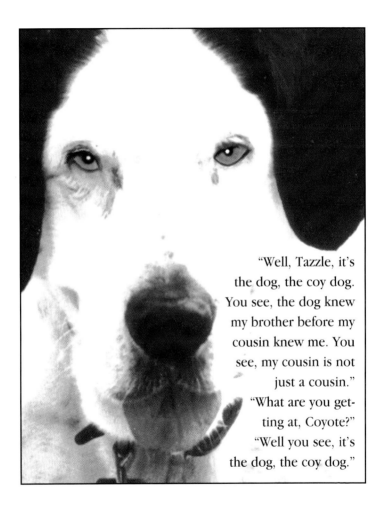

"Well, Tazzle, it's the dog, the coy dog. You see, the dog knew my brother before my cousin knew me. You see, my cousin is not just a cousin."

"What are you getting at, Coyote?"

"Well you see, it's the dog, the coy dog."

MIKE'S CORNER

MIKE MINNOWFARMINMIN SHUCKED the last of a score of cobs and dropped the corn into a round tin tub with the others. Then, since no one else was home, the little guy, hair parted in the center, revolved the staircase upward to his bedroom and fished out a jar from beneath a beige sweater in his dresser drawer. Unscrewing the cap, Mike marveled at his most secret and treasured possession, a corner. It was the corner of something. He didn't know what that thing was, but its corner was now his. The thing could not be wooden, because the corner was not wooden. The same sort of deduction could be applied to materials such as metal, Jell-O, and anything yellow, since the corner had no yellowness.

After years of laziness or indifference, Mike suddenly felt it necessary to wander out of his house into the wild blue world in search of an object missing at least one corner. Of course the corn couldn't be left alone, boiling and smoiling over the stove. A society gentleman named Bentley Borridge would be brought in, and was brought in to oversee the corn's progress while Mike was abroad. Sir Borridge was so

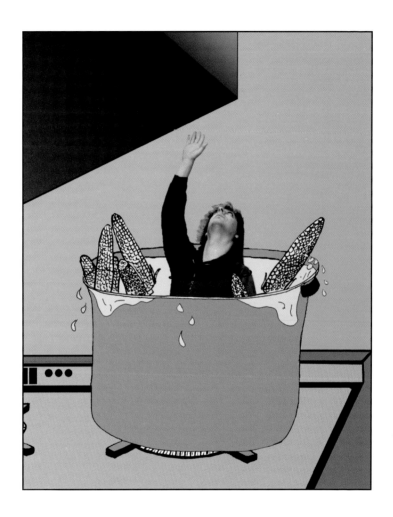

well versed at the growings and cookings of corn that some called him the Town Corner.

With Corner in pocket, Mike strolled the streets of, you guessed it, Nantucket. Every phone booth and street sign was so complete in its corners that Mike was sickened. While checking the hidden corners of shelftop foodstuffs in a supermarket, four large men cornered Mike in one of the aisles and abducted him. "Oh God, not abduction," thought Mike.

After several days of listening to his kidnappers squabble with one another, it was announced to Mike that a package had arrived for him. They freed his hands, and he opened it. Old Borridge had had the sweetness to mail a couple cobs of warm, buttery corn. While smiling and feeling tender inside, the lucky little hostage gazed at a music box resting on the mantel. Its front four corners were in view, but the back ones—who was to say? Needless to say, the box was not wooden. Mike inwardly recounted his assets. "Okay, I've got a corner, I've got cobs, I've got Borridge at home, I've got abduction, and I've caught sight of this nonwooden music box." Mentally consolidating, he reiterated "a corner, cobs, Borridge, abduction, and a box." And once again, "corner, cobs, Borridge, abduction, box."

"What are you thinking, you traitor?" demanded big goon #1.

"Well, just this: corner, cobs, Borridge, abduction, box." At that, big goon #2 withdrew a pistol and jabbed its butt into the soft round pallet of skin at Mike's temple. Through the corner of his eye, Mike noticed that the weapon was missing its lower left corner. Of course, being a metal object, the gun was excluded from such secret considerations. Slowly the unfortunate one heard the trigger crackle forward. No one present thought the goon would fire, but he did, and because #2 was blind and had lost the smelling in one nostril, he missed entirely despite the proximity to the victim's head.

The ensuing silence was broken by the tiny tinkling of a melody. It was a simplified version of "O Come Yonder, Ye, O Ye Who Doth Come Yonder, O," by Margaret Hobbs Mellington Prance. Though no one present recognized the obvious melody, one semi-bound individual did notice that the music came from the direction of the music box. The bullet had not only pierced but spun the unfortunate icon, thus deeming it backfaced.

Mike Minnowfarminmin suddenly jerked his hand and grabbed the hot barrel of the gun, shot his legs free, sprinted for the decornered box, and abducted it as he flew horizontally through a picture window. He hurried his way home, crammed the music box and its reunited corner into the jar, rehid it under the beige sweater, and paid Borridge ten bucks and change. Years later, industry wanted the nonwooden corner, and though Mike had bartered to allow for its abduction, he withdrew his offer at the last minute, claiming that he would rather keep it and spend the time concentrating on this "thing" which had apparently fallen and broken in his kitchen.

THE DAY THE ERA CHANGED

THE DAY THE ERA CHANGED was January 20. It happened at exactly 6:10 P.M. The change occurred everywhere, and the change affected everyone. It's not that people thought differently, or said different things. For example, Mrs. Grace Loon might have said something like, "I think I'd like an egg salad sandwich," before the era changed. After the era changed, she could be heard saying things like, "Is that…oh it is…I knew I would find this jar one day," which really is very similar to the old-era sentence. People didn't feel different either. For example, Henry Ropath felt "fine" two days before the era changed. Late at night, after the era changed, he felt "maybe a little bit depressed…but fine." He always felt a little depressed on January 20 because it was the anniversary date of his first marriage.

When the era changed, the physical surroundings were left intact and the same. The plants, animals, volcanoes, gardens, the sea, other solar systems and galaxies, a pulsar, etc., all were the same after the era changed as they had been on, say, January 19. Even weeks later, and years later, they had

only changed the exact amounts that they would have anyway. What's more, the spiritual outlook of the universe remained as is. Belief systems, gods, metaphysical subatomic synchroneity, and other such concepts all worked the same way after the era changed. And yet somehow everything was shockingly different. In some ways, in fact, the new era had not a single thing in common with the old era. It's actually quite amazing that both eras could have existed in the period from 6:05 to 6:15. And the eras being so incompatible, it's almost preposterous to contemplate the fact that they were back-to-back when the change occurred at 6:10. But they were back-to-back at 6:10.

Jen Istin, a neurophysicist, was looking directly into an electron microscope at 6:10 when the change occurred. She had stayed an extra hour at work to finish gathering data for a report which was due in four days. What she was looking at was called "Carboa." The Carboa was curly and black at 6:09. She withdrew her eye from the eyepiece at 6:09:24 to check the clock on the wall. She reinstated her view at 6:09:49, and right around the coming of 6:10 she noticed that the Carboa suddenly seemed brownish instead of black. She blinked and withdrew her head again from the microscope. Off to the side, she noticed that Kevin Imflim had turned on a small

desk lamp several desks away from hers.

"Could you turn that off for one second?" she asked Kevin. With the light off, the Carboa appeared black as it should. Apparently, some light from the desk lamp had leaked into the specimen vault of the microscope.

Is it possible that the new era was so different, and that the change was so sudden, that everyone just thought it was the same era still going on? After all, with a new set of parameters and a new set of subjects, it's possible that the same algorithms would apply. No one stopped to wonder about the new implications because no one even seemed to acknowledge the hugeness and the vastness and intensity of the change. No one even had minute fluctuations of awareness, never mind the devastating emotional strain and stress that normally accompany such life-changing events. Somehow people managed, in this situation, to save millions of dollars in therapy, and certain insurance companies must have avoided utter demise. Billions of pounds of paper to print new, updated history books were saved because no one seemed to realize exactly what was going on. Evangelists could have had a field day, but they didn't bother because they missed the boat. Generations later, our children's children's children could tell their children that their ancestors

had been there, doing some trivial but thus memorable task at the moment the era changed, but they won't because they didn't recognize the crucial nature of the sudden change.

Before the era changed, a Persian cat named Samantha was cuddled into a ball of white and silver fur. She had sunk comfortably into a blissful hiatus from her daily routine of mouse catching, staring, playing, wandering, disdaining, and having many other naps. At 6:09:40 something seemed to awaken her. She opened her very big, bluish green eyes slowly and paused for a moment, still half asleep. At 6:10 she extended her paws far out into the most relaxing and cathartic stretch that she had ever had. She then fell back asleep into the most blissful sleep.

LITTLE DENNY DANIELS

DENNY DANIELS FOUND IT GENERALLY impossible to avoid the temptation of licking every lollipop he saw. However, according to his dentist, there were "no problems" so far. It was a smooth Saturday in the warm, yellow, and fraternal environment of McNorton Thickcheek's barbershop. Denny couldn't say that he liked haircuts, but Mrs. Daniels had never heard Denny complain. From a cushy green seat Denny gazed through a large pane of glass at the revolving American colors outside, then at the end table piled high with back issues of *Outdoor Life* just between the old oak door and the rotting orange couch.

His eyes moved inward to the point of contact where Thickcheek's hand held a shaving blade against the freshly whitened fat cheek of a struggling round businessman. The strokes were so even and cautiously hypnotic that Denny's gaze almost did not continue its path to the fishbowl full of colorful lollipops on the corner of the long counter.

It was slow, strategic repositioning that found Denny on the stool by the counter's end. First a yellow one was

unwrapped and planted between the tongue and small saliva gland underneath. It remained, and a red one was soon added on tongue-top. Soon a green accompanied the yellow underneath, then a purple above, and in four minutes' time every lollipop was helping to pry the young boy's mouth open. As hard as he could he started biting and crunching. Lollipop substance was pressed fiercely into the hills and valleys of Denny's new molars. Every tooth was soon cemented with the stuff, and additional crunching adhered the top globs with the bottom, and jaw motion had come to a mandatory freeze.

Thickcheek was repeating his highly convincing theory that a baseball game can be predicted by the relative strengths of the teams' shortstops when his eyes wandered to the twenty-some odd small paper dowels sticking out of Denny's mouth. Thickcheek flinched, and sure enough his blade cut a straight line clear through the round man's cheek, just nicking the edge of his tongue on the inside of his mouth.

"You won't tell anyone I made you say 'ouch,' will you?"

"Oh no," said the wounded, "mum's the word."

Thickcheek walked over to the pay phone, slipped in a dime, and called Denny's dentist.

"This is really no problem at all," said the dentist. So the

shaving was completed. The businessman had fun sticking his tongue through the slit in his cheek and just missing the moving blade. Thickcheek had learned to simply shave along the grain of the slit, and not against.

Denny loved the way rainbow flavors dripped uncontrollably down his throat.

"Next," hollered Thickcheek after the round man had paid. Just then a fireman ran in the door, withdrew a handgun, and shot a hole directly into the wall.

COURTHOUSE DESIRE

"**M**AKE YOURSELF INTO A MARKETABLE ANDROID," he said as I was leaving his office. What was I to do with this? How was I to interpret this faction of peculiar indoctrination? Perhaps, I thought, he is just a mindless, clueless, gullible shoobie.

Nonetheless, I gathered some parts. I gouged out my brain and inserted a Commodore VIC-20. I shoveled out my entrails and filled my tummy up with 64 kilobytes of RAM.

That night I attended a seminar for marketable androids. The seminar was sponsored by a group called the Mindless, Clueless, Gullible Shoobies. As for descriptivity, the color was light tan.

"I am proud to introduce tonight's speaker," said the master of ceremonies, "an 8-ohm Powercone."

The speaker spok: "I have never had a courtship with a courthouse before. Goodbye. Leave. FIX THIS CRAP!!!!!"

The MC fixed the speaker, which had broken. I found I liked being an android. I felt I could market myself just like that speaker. Just like it could market itself, I could market

Self-Portrait

myself. I think this seems wonderful.

The next day a phone rang. It was Judge Whimples Gavel. He thought I should come serve duty.

"Sure, I'm all duty."

The 8-ohmer ended up being the one in trouble. I would've voted "Yes" but I voted "No—hang the mother." It's great being so smart-assed, I thought as I whimpled home.

AIR TIME

SCOTTY FROM *STAR TREK* boarded a 747 in an effort to fly to Europe. Most things in the airplane had been painted bright beige, he noticed. Even his Sanka had a layer of bright beige–colored paint floating on its meniscus. The stewardess, whose face had been painted bright beige, asked Scotty from *Star Trek* whether he would like any more bright beige–colored paint in his coffee. He said no, but thanked the

woman. The stewardess, who was wearing a bright beige smock, left him alone, and he decided to catch some shut-eye.

About twenty minutes later, all the passengers had become comfortable in their seats. Some had reduced their oxygen so that they could catch some shut-nose. It was at this time that there was an announcement on the speakers: "Paging Scotty from *Star Trek*. Paging Scotty from *Star Trek*."

Scotty from *Star Trek* awoke and trotted down to the captain's cabin to answer his page. He had a call, so he took the radio receiver. It was Kirk. In fact it was Kirk and Spock. And Sulu too.

WAITING ROOM ANTICS

ONCE THERE WERE FOUR HUNDRED pieces of crab brain resting on a gray insurance company seat. The three crabby people sitting in this cold, clean waiting room simply stared at the brain pile in disbelief. The crabbiest person in the room, Mrs. Cosmo McPhim, arose and exclaimed, "I am in disbelief!" Just seconds later, Joe Scratcher erected his small, pudgy

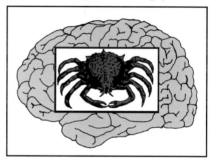

body and said, "I hate you, McPhim." This insurance company lobby employed 1,250 janitors, and they all worked—always. At least 1,100 of them had noticed the brain piles. Two hundred of them yelled, "Sit down, McPhim." Mrs. McPhim sat down.

Three years, one day, and six hours later, a secretary entered the waiting room and announced, "Scratcher, get your butt in here. You've waited long enough. We're ready to

discuss insurance!" Unfortunately, the crab brains had corroded and transformed into long tubular arrays of sticky fungus. Scratcher, McPhim, the third crabby sitter, and at least 1,050 of the janitors had been entangled and entrapped in this horrible labyrinth of putridity.

"Come on, Scratcher, get your butt out of that fungus and let's go talk some insurance!" Scratcher moved the one finger that could still be moved and exclaimed, "I hate you, McPhim." The secretary said, "I'm waiting, you bastard. Get out of that crab fungus and come with me!"

"With you?! What is this 'with you'? Don't you see this fungus? Tell me about 'with you.' You tell me about 'with you' and I'll tell you something about insurance!" Mrs. Cosmo McPhim rotated in her fungus and exclaimed, "I am in disbelief."

"I hate you, McPhim," said Scratcher while gazing at a window across the corridor in an office. Outside the window, he could see birds and planes and rockets and a donkey.

"Get your donkey butt out here, Scratcher, we're waiting."

"Tell me 'we're waiting'! Fungus!"

"I'm warning you, Scratcher."

"I hate you, McPhim."

"I'm in disbelief."
"butt out here."
"Fungus."
"McPhim."
"butt."
"disbelief."
"Scratcher."

TEA IN BRAZIL

REBECCA SPILLITT, ALSO A MEMBER of the Women's
Garden Club, was at my door.
I invited her for tea and Brazil because she
recently became my beloved neighbor.
I opened the door and assisted her in carrying the tea
to my golden brown dining room set.
She was so quick about firing up a conversation about
Pilgrims.
I didn't have a moment to ask her why her hair was in a
dead bun
or why she wore my dress. She said that
Pilgrim ways had to come back
and that she would perform her best for the garden
club. We drank the
tea but it was firing hot. The phone rang.
It was Mr. Spillitt calling from work.
While she was on the phone in the kitchen
I slipped into the bathroom to jab on more and more
golden brown makeup.

73

We achieved hell back at
the tea table. And I asked her what Mill had said.
She said he was hot and I asked
her if she wasn't also. The scary thing is that
I looked her in her eyes and they
looked like my mother's. I asked her if she knew
my mother and she turned pale and
started to run out of my house and as she
reached the edge of our
freshly mowed deep green lawn, I noticed her
closely and it turned out that
she was me. I ran in and got her
tea and brought it out to her. I said
take your Brazil, you mad beast.

THE CASE OF THE YELLOW BALLOTS

BALLOTWOMAN SMITH CAREFULLY checked a young lady's identification, put a mark by her name on the computer printout, gave her a ballot, and watched her fill it out and place it in the box. This procedure kept ballotwoman Smith busy for the greater portion of February 12.

One time the ballotwoman went to the bathroom and brought the ballot box with her. When she returned to her place, she was beaten by ballotwomanbeater Ericson. Ericson told her from now on she must go to the bathroom into the ballot box, and not leave her post.

The end of the day doth come. The day had gone well with the exception of the fact that ballotwomanbeater Ericson was eaten by a ballotwomanbeatereater.

The box was opened on a table in Sue Scew's office. Sue Scew and her team began to tally the ballots. It did not take much time for them to discover that each and every ballot had the same name written on it, "Dr. Pvoo." The strange part of it is that each ballot was written in the same exact handwrit-

ing, in the same exact part of the choice line. And to peculiarize onward, each ballot was filled out with the same brand of yellow magic marker. What's more, this particular magic marker company had discontinued its yellow magic markers after selling one of them.

Oh gosh, what was to be done? Had all of the ballots been filled out by the same person simultaneously? Sue Scew decided to start by looking up the word "yellow" in the dictionary. To her astonishment it could not be found! Miss Scew figured that her sister must have borrowed the dictionary.

BEATRICE OGGLEMAN AND THE RESPIRATOR

BEATRICE OGGLEMAN ROLLED OVER and adjusted her respirator. It was a typical old-age-home morning. The oxygen was low that day. Beatrice had a fine sense for oxygen. After several minutes she realized that the respirator was still not going fast enough. So she reached over and turned the knob on the respirator completely clockwise.

Her lungs started opening and closing seventy-one thousand times per second. She was thrown, by the motion of her lungs, all around the room. She floated and smashed into the ceiling and then fell again to the floor.

Beatrice Oggleman and the Respirator: Part II

The machine still pumped air, and Beatrice was shot all around the room. Suddenly she was shot out the window and into space.

Finally, in space, her lungs no longer pumped air. She was pulled by gravity back to China.

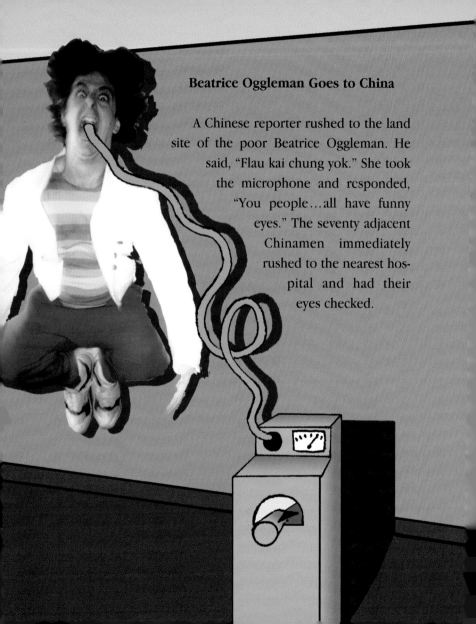

Beatrice Oggleman Goes to China

A Chinese reporter rushed to the land site of the poor Beatrice Oggleman. He said, "Flau kai chung yok." She took the microphone and responded, "You people…all have funny eyes." The seventy adjacent Chinamen immediately rushed to the nearest hospital and had their eyes checked.

SUN BURN

FOUR ANGRY SHARP-TOOTHED FISH managed to get their paws on four fish-scuba water tanks so that they would be able to enjoy land-walkage. The angriest fish of all, a fish named Bill Fishman, was the first to throw the huge metal tank of water over his back and position the mouth mask of his scuba unit over his mouth and nose. The other fishes also did such things before land-walkage was attempted.

Meanwhile…in a small farmhouse by a dusty road in southern Idaho, an elderly woman removed the last curler from her hair and answered her manila-colored wall phone. It was her elderly husband, Ron. He would not be home until 6:30. Six-fifteen would be an unattainable goal to set. So why even set it? Six-thirty would be a fine time, according to the elderly woman, whose middle name was not Bill, and whose maiden name was not Fishman.

So the fishes scurried hitherforth and bitherdorth until they had reached the shore and they walked up on the beach for the first time since St. Patrick's day of '82. On the beach a film crew was filming parts of *Being There* which later would

be scrapped on the editing room floor after a unanimous decision to do away with beach scenes in general, in all movies. Director Bagel Bark swiveled on his chair and shouted in the direction of the fish, "Okay we're gonna do a take. 34-51-12-8-damnit raise those flare reflectors-2-3-4-and-9-we're gonna wait for that cloud to pass-take 5-take 9-50-on the truck-okay-places-scene 34-51-12-9-3-2-1-action."

The fishes were so bewildered and bumble-blasted by this spewing of seemingly meaningless blabbermint, this flaunting of neo-ambiguous information, that they headed right back into the water and swam to a psychiatrist. The fish-psychiatrist could not meet with any of them, unfortunately, until 9 A.M. June 17, 1998. But he had a given dish of, water of course, but also of small white and blue mints in silver aluminum wrappers and plastic ribbon strips. All was not lost.

At the farmer's market Farmer Ron picked up his last bucket of apparently unsalable cow-quail-beans and went walking in the direction opposite to that of his home. In fact, he never did reach home because he was mis-faced direction-wise. He never reached anything. Nil. Not trees, nor woods, nor forest, nor cities and pavement or bodies of water. Just nothing. Really. Nothing. He did actually see something, but nothing worth mentioning—just a little black box. One with

blinking lights on it. He didn't even think to bend and pick it up. But he picked it up. It was old and new and fun and last-longy and squooshy and edgy and smiley and with fungus all over it. It smelled of fish. There was a button on the back, Ron noticed upon pickage up of said box. It said, "Don't push this button" next to the said button. It said, also, "If you push this button, then terrible and great and wonderful and pungently odorous and musical things will start happening and they will never stop. What's more the sun will not burn out in 2 billion years, as it is currently expected to."

After reading this painfully silly and pretentious inscription, Ron scratched his eyeball and thought for a minute. He wasn't thinking about whether to push the button, he was thinking that he had forgotten to pick up his phone-answering machine, which had landed in the repair shop after killing a caller with a loud high-pitched screech. In terms of the button-pushage dilemma, it was not actually a dilemma because Farmer Ron was a relatively conservative individual who wouldn't think of pushing a button which warned of not pushing it. He put it down and walked onward toward nothing.

CLOSET CASE

THE BEAK-HEADED DOCTOR cradled a dislodged pile of medical whatnot between his forearm and bosom as he scurried surreptitiously through the ovular corridor. Looking left and thus right, the malice-minded pagan antihero made his clumsy way into a supply closet. Before he made motions to proquire a long tubular needle extension wand, it occurred to his busy-bodied head that there was a male and female nurse-couple fornicating in the closet and periodically brushing the doctor's tailbone with a kneecap. After the doctor overcame his initial frustration of desire for an experience of his own not unlike the one presently being enjoyed by the unknown party of two, he belittled the situation and motioned onward toward the large box of needle extension wands beneath the small shelf of a large metal locker unit.

After the box-brained beagle huff-puffed through the oversterilized wand assortment, he grabbed the appropriate death tube and reached for the exit knob. To the dismay of all three closet constituents, the pus-breathed medical madman tripped on a pile of soon-to-be-repaired orange extension

cords and fell sideways onto the back of the diagonally down-faced female fornicator, and accidentally lodged the needle wand tip deep into the right nostril of the floored, horizontal male intern. He thus pulled the unfavorable tube out of the young dribbler's head, creating a vacuum and encasing a tubular array of blood, pus, and mucus inside the retrieved unit-stick. He verticlated and refumbled for the outward passage. Without graceful reproach, the dog-horned doctor slimed flatly out of the unfortunate closet.

With several quick twirl-hops, the disorganized deacon of science floundered into the second whitewashed patient-quarter doorway on the left. To the abhorrent dissatisfaction of the vulgar nostril-piercer, his empathizeable ex-patient had been recently euthanasiated by another, more important member of the ever-rigid medical hierarchy. Demoralized by the lack of a supposed opportunity to do evil deemed-doable, the old chapped-chinned, adult-minded pediatrician pulled a derolled hot dog from his suede lunch sack and repopped the reheated end into his leather mouth. After rejournalizing a preconceived log entry, he de-escalated to ground level in order to board his silver and gray Chevrolet Vega as part of a home-going routine.

Heartworm

J IM GOON WAS SITTING IN CLASS when he suddenly realized that there was a 40-foot worm inside of him. Before Jim had time to negotiate, the worm grabbed a ventricle of Jim's heart, ripped it off, and ate it.

A Burning Sensation

I WENT FOR A WALK DEEP into the center of the earth. Hot lava and red-brown boiling mud oozed by my burning face as I swam inward. Large sizzling boulders cracked in the distance, echoing through the mud. Small inner-earth lizards crawled by, vehemently eating all forms of drying bacteria. I pulled myself through the crusty rock section, tasting rare metallic substances and gasping for nonexisting oxygen. Being thousands of miles away from the surface and my dog, Jerry, I began to get lonely. Red mud became darker. Rock became black and liquidic.

Finally I passed through the ghastly center—a Spaulding golf ball. It was billions of degrees Celsius. It burned me into ashes, but I kept on going. By the way, my name is Bill, but my friends call me William Henry Henry Thuckforth Table Bitch.

Part II

The madness of scorching boiling rock at high gravity and low central rotating velocity decayed as I recrossed inner

crusts. Soon I approached wormy muddy soil and I knew it would only be fifty or so miles until the breakage point.

Wakey, wakey, rise and shine, soon it will be breakfast time. The sun is up, the birds are up, and now it's time for you to get up.

Then it finally happened. Boom-smash, scream skull smash, quick flip shoot sky and I had fallen into the sky of China.

Vroom faster faster as I passed by Chinese parachuters and birds. Finally Shcramowza!! I landed on Chinese soil with my shovel in hand—the same shovel I had used to start the hole in my backyard. A Chinese Buddha came up and said, "I am Jesus. You are a skin-ball. I serve you no move. We are the all-bad sex squash. Stop cowboy listen to blues downtown."

THE SECOND COMING

THE BELOVED BABY BUBBLESCUMP Bublatt sat in her room and awaited a message from carrier pigeon Tim Porcupuppy. Because Bubblescump had been taped by her parents to the floor with Scotch tape, she could not do much besides urinate.

Tim finally flew in with the message. It was, unfortunately, written in Old Spanish, so Bubblescump could not yield its meaning. She had no knowledge of Old Spanish, New Spanish, or even English yet.

So she brought it to the famous Spanish scientist Pablo Smith. Pablo carefully examined the document, twisting it far and forth, when suddenly he became aware of the dangling broken strands of Scotch tape on Bubblescump's buttocks.

Then there was a nuclear war and the baby's parents had been killed anyway by police dogs. The carrier pigeon was reincarnated as a cockroach.

SPY STORY

I WAS A SPY FOR the FBI. Then I realized I was just spying my life away. Do you ever realize that? It starts to seem like a waste of time.

It's too very old of a sport. It is Muzak in its finest hour. I had had enough.

Then I started spying again. When you think about it, why not? Did you ever think about it in that way?

But then I just stopped spying. It just started to seem like I was spying my life away. Imagine spying one's whole life away! So I quit for a while. But then I rejoined. A guy's gotta spy sometimes, even if he is spying his whole life away. But I quit, and I felt the time for quitting had come. So I guess that's it. You know, do you ever realize that something's it? I know I did. I called the FBI office, talked to my old boss, and

I said, "You know, boss, spying ain't bad." He gave me my old job back. It was like old times. I thought I was spying my life away. I really was, and the funny thing is that I knew it.

I was thinking of quitting. I quit after all, but then I joined up again. Boy, it felt so damn good to be back. I love my boss. I told him I was going to have to quit. I said, "Boss," I says. I says, "Boss, you know a guy can't just spy his life away!"

BASIC ELECTRICITY

Chapter I

FOR THIS DANGEROUS yet exciting experiment, you will need an egg and some wire.

Hold one end of the wire and stick it into the side of your neck. Push the wire into your neck until it comes out somewhere else. Then grab both ends of the wire and pull so hard that the wire slices through your neck and comes out. Then place the egg inside the big slice in your neck and try to crack it by moving your head around.

❏ Review Questions

1) What does this experiment show us about static electricity?

2) Suggest a way to do the same experiment without the egg.

Tales of a Cold Winter

Frostbite

NOTICE

To Avoid Confusion...

THE INSTITUTE OF DAYLIGHT SAVINGS has revised the Daylight Savings procedure as follows: Every forty-two and one third minutes, three sixteenths of a second will be added during April and May through May twenty-sixth, four thirty-thirds of a second will be subtracted during September and October, and four hundred and twelve three hundred thousand nine hundred and twenty-fourths of a second will be added during other times, thus eliminating inconvenient, confusing, and unnecessary biannual alterations. This excludes Eastern areas ninety-eight degrees north of the equator and Central areas thirty-six degrees north of the equator, which will divide the above time alterations by pi and add twice the latituduler coordinates squared. On leap year and every other non-leap year, four and three thirteenths of a second will be subtracted from each altered interval with the exception of those between February seventh at seven thirty-three P.M. and February ninth at two A.M. and thirty-two and forty ninety-thirds of a second.

For those who do not wish to adjust their clocks and watches manually every forty-two and one third minutes and three sixteenths of a second, we have several automatic time alterators. Model gh-87098274LKJ98, for example, which sells for thirty-two dollars and sixty-one and four elevenths of a cent, is 94.2057394857 percent accurate.

For more information dial 1-800-789-347-723-673-347.9, extension gheidjh, normally, or 1-800-628-458-138-246-972.5, extension xxaythgton, on every third odd midnight.

MOXI'S HOOBLUB

I REMEMBER BACK IN 2024 when Lumps of Chick-Henry used to play at Moxi's Hooblub. The other guys in the dorm would say things like, "Hey, come on, Lumps of Chick-Henry," and we'd go. Lumps of Chick-Henry was great—so dark but with a faint glitter of real brilliance. I loved standing there and absorbing that sheen. Like if you blow out a candle and then there's a pause, and then there's smoke, Lumps of Chick-Henry was just like the pause. I even

bought Lumps of Chick-Henry products, like the "Mock-up Wipester." Of course it broke. I went down to Moxi's and when I got home at 3 A.M., I found it had fallen and broken into about eighty pieces. I didn't need the souvenir anyway, when I had such a cogni-print.

Later that year things unraveled for TLOC-H. For a bunch of painters sprinting in a dance poise, they found they couldn't even tune the six zithers. They were supposed to be about painting, dance, and archery, not spelunking, floor-looming, and needlepoint. Oh well! Right—oh well. The hell with oh well, we're talking about tuning up those zithers and going for another round of Lumps of Chick-Henry. But one night that guy with a spike coming out of his head walked right into Moxi's Hooblub and punched Moxi right in the ear. So then it was mum-being-the-word for Lumps of Chick-Henry. They couldn't tune the four zithers, and both zithers stopped after the ear punch. I wished I had my Mock-up Wipester. They had been so pale but so exuberant. And things became shattered, dull, red, and fiery. Really there's nothing to look back upon, just Lumps of Chick-Henry.

PARALLAX

THERE ARE TWO PEOPLE: John Efi and John Efi. If there were one person, then why does John stand over his own shoulder, watching the other thresh pemmican like barley?

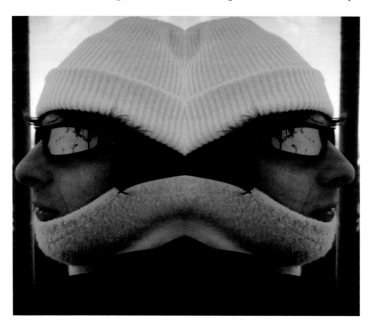

Confounded as a hart in gaze by estuary edge, the upper Efi retreats.

"How is the cathedral of wisdom today?" lashes Efi, the sitter. They redichotomize.

"It's your disparaging remarks that fertilize my enmity."

"You're rough-legged."

"You're an ass."

"You're black-throated."

Reconvening by the buckboard, the Efis refute any hegemony. Though discourse is far from eleemosynary, its whirring fades and falls by the penumbra of the buckboard. John cognizes a final comment to be a feint in the context of his own ahimsa, and the donkey scuffles at the squawking of a grouse.

"John," says Efi, looking into the eyes of his now physically separated clone, "you're a conch."

I WILL NOT GO BACK TO WINOOT

I WILL NOT GO BACK TO WINOOT. It's because of an experience I had there. Actually, I was passing through town, and with nothing to do I went to a Groucho Marx movie. That was the good part. The bad part was afterward. I must have said the wrong things to those street people because they clamped my head against a building. I mean it was tight—it was a q-clamp, and it was c-shaped. I hadn't seen a q-clamp in years and now there was one clasped tightly around my skull, fastening me to the Morriff Bank, and the street people were gone. Frustrated, I thought up a poem.

I tried to dislodge, to no avail
Children threw sand from their pail
A woman gawked and raised a tiffy
A puppy lifted his leg and skiffled

A cop stood glaring and penned a ticket
While Gus from the bank turned on a spigot
My brow beneath the q-clamp itched
A mugger came by and leached my pocket

A guy who said he knew me in school
Said to clean off what he thought was drool
A guy who said he had fired my boss
Invited me to what he called an old-fashioned
ring-toss

I tried again to unwedge my head
Some skin peeled off and I aborted mission
With darkness afoot, hunger came
I started to wish I had someone to blame

Just when I thought I'd had enough
Some punks came by and acted tough
A big one said, "Man, I feel vivified"
He punched my head two times

A mason cemented my feet to the brick
He said, "If I were you I'd leave this town quick"
Hurting, I wished I was still watching Marx
But a Marxist in Winoot is only a farce

TELEMARKETING

"**D**EATH BRACELETS," announced Rigimo Bault. The voice Rigimo heard through the phone was squeally.

"Look, I dialed your 1-800 number and all I heard was a loud, deafening tone."

"Oh, really." Rigimo pretended to be interested while directing his true attention to the cigarette butt he was squishing into his black marble ashtray in an act of extinguishment.

"Yeah, a guy wants a bracelet and ends up with a busted eardrum and then he's gotta call information and talk to a butt-wipe operator to get the other number."

"Sir. Death Bracelets values each of our customers like we do no other customer, so we are wicked sorry for the tone. Actually, you can make a phone line complaint by dialing 1-800-bitchat." Right at that moment a telephone computer mistakenly charged the customer and Rigimo $92.18 each for the call in progress. Neither the slick braceleteer nor the whiney dork were aware of the charge. "Can I get you a bracelet?"

"Look, I want a bracelet made with silver, azurite, red-

wood, cobalt, ruby, sea glass, Formica, petrified wood, yellow tungsten, black onyx, recycled paper, corrugated cardboard, treated burlap, and…did I say azurite?"

"Yes sir, and you're in luck. I have that exact bracelet. It's back in the death closet, so you'll have to hold on for a couple minutes." Without waiting for a response Rigimo Bault pushed the big red "hold" button and then sat there for a few seconds. He resmooshed the same butt in the same ashtray and swiveled his chair backwards.

Down at the end of a very long corridor there was a door which led to a stairway. At the top of the stairway there was a ceiling hatch which opened to a crawl space which led to the death closet. Unfortunately, that crawl space was constrictive for such a claustrophobe. Rigimo's watch beeped once, scaring the crap out of him and causing his head to slam the ceiling. The death closet door was stuck, so Rigimo leaned back and kicked his shoes into the door as hard as possible, and it flung open. "Aaah, aaah, aaah…aaah, aaah," chanted distant operatics to signify the onslaught of death. A dusty mirror hanging against the right wall of the closet reflected Rigimo in the image of Elaine Nardo from *Taxi,* but Rigimo didn't notice the aberration. In front of him, he looked at the hundreds of cupboards filled with bracelets. After doing some

mental calculations he pulled a lower-left-hand knob and unstashed a Ziploc sandwich bag filled with three bracelets. Hesitating, he pulled the gold cross out from his chest, clenched it, and draped it over his black T-shirt. A soft clinking was heard as he carefully withdrew the middle bracelet and reziplocked the others. He closed the drawer and right then his cross melted off its chain onto his lap. His heart popped. Not scared or surprised, he farted and squirmed quickly out of the death closet and back to the phone. "Yep, one left."

"Look, you put me on hold for ten minutes and I'm sitting here thinking ccchaugh ccchh cahaugh augh chch help. *Zip clunker click. Dial tone...*"

Rigimo Bault tried the bracelet on and admired it, twisting his wrist left and right. He reached and reshmooshed the same butt in the same ashtray, and as he smirked a gleam sparkled in his right eye.

A Guide to Writing

THE FOLLOWING EASY-TO-FOLLOW-EASY-TO-SWALLOW steps will help any Joe write a decent story. Okay, let's start. First one needs some sort of introduction, shall we call it a "launching pad"? We shall. I'll let you in on a little trick: just start out with, "Is in Islington bile." For example, "'Is in Islington bile,' the putrid witch screamed while running through wicked sewage." Another example exploits the adverb: "Is in Islington bile, slowly, shrewdly, tactfully." Or if you want to get creative, just start out with, "Is in Islington bile." Period. You probably should save underlining for later in the story, rather than just springing it on the launching pad. "<u>Is in Islington bile</u>," for example, sounds pathetic.

Development. Period. What a section. It wreaks of glory. For those junior-Shakespeares who have predicted that there might be a trick for this section—you've got a thumbnail on the ball. Here's the trick: take your launch pad and let it blow into space like a rocket. Here's what I mean, kids. Hey, college kids! Here's how to do it!

"'Is in Islington bile?' you ask," asked Islington. "I can't

respond to that. I'm a is in. Islington bile. I'm a sin, as in, as in 'Islington bile.'" You get the point, you cute little Shakespeares.

 Of course you need a clincher. Just when you're ready to take 'em home, try this for some clinching: throw 'em for a loop and sock 'em the sox. What I mean, is just start talking Boston Red Sox. Sure—you can do it! You can because you're the writer. And you're a kid. A college kid!

"Is in Islington bile," said Lorna to her husband, "means nothing to me, honey. All I know is the boys are playin' some ball tonight!" She bit her hot dog.

"Yaz is on tonight." He smiled.

"Oh Yaz is the best. He's the best. Oh God."

"Oh yes—yes—Yaz, take 'em home." Take 'em home, Yaz. TAKE 'EM HOME, YAZ.

PIGGISHNESS; HOGGISHNESS

THE YOUNG, TIRED CLAM exclaimed, "I am going to keep this robe and other garments to myself."

"You selfish shellfish," exclaimed his mother.

"Mom, you're a burnout," exclaimed the clam's father (to his own mother).

BESS

BESS DANGERCITY WALKED OVER to her Spam cupboard and pulled out a can of Spam.

"Shit, this is wormed!" remarked Bess in an all-too-feminine way.

On another day, in another land of green, Bess's father wished several things to be true. The first wish to be true of, was an examination of the fricative. Second be do be true be combo fricabump.

—End of Chapter One—

❐ Review Questions:
1) Where does Bess's Paw obviously live?
2) What does this chapter imply about a worm-base?

Bess's linguistics teacher looked his wide slits into her face and said, "Hackenpan stickenpan" and snuffed his nose and burped his lungs. Bess was not disgusted, she was bored and exhausted. She faded off into a dream.

She dreamt of a tall man with short brown hair and grayish blue work clothes. The man had lost his eyes due to disease or accident and was left with mere sockets. The dream took place in a car, the man's car. He was driving and eating junk food. The man could easily put his trash in the wastebasket on the driver's side door, but he was too lazy to bend down so he stuffed things in his eye sockets. At the time of the dream, the man was stuffing the uneaten remains of his hot dog into his left eye socket, smiling and driving down the road.

After awakening from the dream, bess [pron.: Bess] found herself scurrying to join her classmates in the journey to out of the class. "Thank God," thought Bess, "the scallion truck is here to fill my pansy with sunshine." So she bought a scallion kabob. It had, on it, scallions, unsliced, unwashed, un-picked; and onions, whole, uncooked, unwashed, unpeeled, unyun; and smothered with a green and black horseradish sauce. Along with the kabob came cukes, seeded, peeled, mushed, squished, fried, burnt, crumbled, and mixed with honey. To drink, carrot/raspberry milk: very thin, juicy, with an egg, thick, with thick heavy cream and a teaspoon of bread dough, unsalted. For dessert, mildly pickled blueberry chocolate cakelettes with a garnishing layer of skim milk frozen on top, below, and in between. And as an after-dinner

mint, peppermint/hamburger morsels soaked in cabbage water, stuffed with lemon Italian ice and 30 percent air. As a fortune cookie, egg-bagel cookies, cooked to a tight crisp and curled around central, edible messages of life. As the message, a wax paper/skim milk/maple candy substance inked with the blood of a Spanish typewriter ribbon and spiced with nutmeg and winter road slush. Thank God for the scallion truck.

—End of Chapter Two—

❐ Review Questions:
1) Compare and contrast every letter
 of the story with every other letter.
2) Get out.

STRANDED

BURTWER WAS THE ISLAND'S ONLY INHABITANT. Thank God he had learned a little janitorial maintenance while he was in the service or the island would be an awful mess. Due to Burtwer's janitorial knowledge, the island was spic-and-span. In fact, it was smic-and-smac. Like I said, when it came down to cleaning, Burtwer was A-OK. Not gonna see any dust blobs on this island.

Part II: A Shift in Island Politics

One time Burtwer was almost rescued from the island, which he had flown to in his helicopter, which still works fine and has gas. The rescue job was coordinated by coast guard aficionado James Kirkpork. James was a lean man, which probably explains why he attempted to rescue someone who had a fucking helicopter that worked and still had gas.

THE AUDITION

H ARVEY HASHBROWN ROLLED out of his big, blue bed and began to sing, "La, la, la."

"Slam it, Harvey!" exclaimed Mommy Hashbrown.

"But Mommy, if I don't practice singing, I won't make exip!"

"I don't care if you make exip. If you sing more I'm going to slam you."

"But Mommy, I don't care if I slam sing exip."

"If you slam I'll sing you exip."

"You exip slam exip sing."

"Exip if you slam, then I will sing."

"Sing you can exip slam."

"Exip slam sing sing."

Dear Harvey Hashbrown,

It comes to my grave bannöre that I must report that you did not make exip. The reason is your singing. It lacks bannöre. You probably never even practiced. You are a shitlog.

Sincerely,
Kiftor
Secretary to the King of exip

Deep within the dark, powerful forest, a wind gliffered through the moonlight. The trees and the leaves on the ground were crisp and very real. The sharpness of a pitch-black silence cut through the air's summer flavor. At the bottom of one particular tree, between segments of the stump, lay a single oak leaf. The leaf was still, as if in thought, occasionally flickering in the wind. Unknown to even the forest's slickest night-watcher animals, there existed a peculiar object under that leaf. This hidden object emanated a bright golden glow. It was the huge but microscopic golden castle of exip. A tiny person, much smaller than a centipede, clad in heavy armor, reached for the drawbridge lever, and the solid gold drawbridge was raised.

Inside the huge golden castle, there was a grand entrance hall beneath a vaulted ceiling that stretched several stories high. Corridors and cases of stairs shot off in every direction. Ornate with Gothic newels and delicately hand-carved rosettes, the one largest stairway curved upward, twisting several times. Wringing and wrapping, twining and twirling, it led to the king's quarters. At the top of this spiraling escalation, by the velvet-covered banister, stood two guards clad in pewter. Unflinching, they guarded the arched portal to His Highness's quarters. Inside that very room, with canopy afloat,

the king lay peacefully sleeping in his king-size Victorian bed. Behind his fluffy velvet-covered pillow, and behind the beautiful, hand-carved, oaken headboard, inside a trap door, there was a little cubby. In the cubby a typewriter was clicking away. It was a very small typewriter. Behind it sat a midget with a long mustache who wore a purple cloak. This small cubby was the office of the midget, Kiftor, Secretary to the King of exip. He was a dedicated man, always with a stern look on his small face. His expression did not shift as he finished the final word of the document.

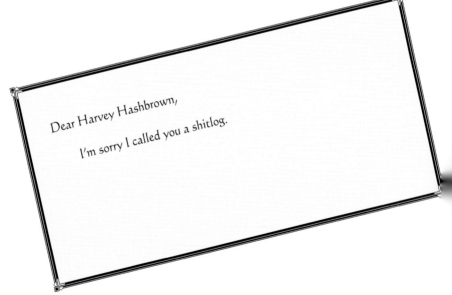

Dear Harvey Hashbrown,

I'm sorry I called you a shitlog.

Book Reviews

BENNINGTON MCBISHOPKUD'S LATEST NOVEL, *Psyched to Wail,* is a real book. When I first saw *Psyched to Wail* in the store, I knew it was a real book. *Psyched to Wail* is good because it teaches you about life — not your life, not my life, in fact not life at all. *Psyched to Wail* is so good that it's like a sun setting over the horizon.

FIRE DOOM IS A FUNNY book. Also, if you buy it, buy one for me too. I've never read it. *Fire Doom* is a fearless novel about Fire and Doom. Both Fire and Doom are mixed together in the book. As well as Doom, Fire is and integral part of one another. A two-by-three-foot poster of this book review is available for $9.91.

Next week we look at Spi Worno's
Danger 'Aneath Heaven's Gut

P.S.

Dear Mr. Coor,

It has suddenly occurred to me that I am going to go to your house and break your fence. I tell you this in advance so as to give you some time to locate a good fence repairman. Come to think of it, I happen to *be* a good fence repairman. Now that I'm writing this letter, I might as well leave you my office number, 601-1180. Just call June, my secretary, and tell her the kind of fence that needs to be repaired, etc. Also, when I say "June," I mean the whole month.

COUCH POTATO

I DON'T KNOW IF I CAN AFFORD FORTY DOLLARS," said Elmwind to the couch lady. "Ya varmint!" she replied. "If ya don' like the couch, then I'm gon' 'tach ya to it."

And thus Elmwind was stapled to the couch. Various customers looked at the couch during the next few days. They didn't ask why Elmwind was stapled to it.

Then one day the couch was bought by industry. A machine shop wanted to test its brand-new shredding machine, so they bought the couch so that they could put the couch into the machine.

Since they were on a tight schedule, the company didn't bother to de-staple Elmwind from the couch. They simply raised the couch with Elmwind attached and began to shove it in the shredder.

All of a sudden the phone rang. One man held the couch where it was while the other answered the phone. It was a wrong number, so they continued.

Elmwind was inside the machine, being shoved deeper in, when he suddenly noticed that the company which made the

machine had forgotten to install the blades! The only thing heading toward Elmwind and the couch was a cotton pad. Just after he made this observation, the machine cut Elmwind into 408 billion pieces. After that, Elmwind decided it was really time to consider what he is doing with his life.

FORTIETH DANGEROUS SWAB

"**F**ORTIETH DANGEROUS SWAB," muttered Q-Tip Inspector Tood as he did what he should.

Part II: Excerpts from a Q-Tips Executive Meeting

"...No, I can't understand why there were over forty dangerous swabs!"

"...could you pass the water."

"Sure. You'll need a glass too."

"Yes, I guess I will..."

Part III: A Man Gets a Letter

Somewhere in the luscious island of Idaho Springs, a man lived in a yellow-green house. It was on one of those yellow-green spring days when this man received a letter. It was addressed to Arnold O. Tood. The man had no relation to Q-Tip Inspector Tood. The letter read:

Q-Tips America

Dear Sir,

Our company is sorry to
regret telling you that
several dangerous swabs
may have how-does-one-say
"leaked" into the public.

 Sincerely,
 The Q-Tips Corporation

The man did not go into his bathroom and get attacked by a bloodthirsty Q-Tip monster. What do you think this is, a bullshit story?

Part IV: The Bloodthirsty Conclusion

To make sure that his Q-Tips were not dangerous, the man went to his bathroom, where he was attacked by a blood-thirsty Q-Tip monster.

Supplementary Report

It was just yesterday that we began the seemingly endless battle against Q-Tip injury. Starting yesterday, our eager technicians have been putting days, even weeks of research into this project. To the families of dead Q-Tip victims, we leave this song of sadness:

> Hey! You've got to hide your love away
> Yes it is
> Hey! You've got to hide your love away
> Yes it is

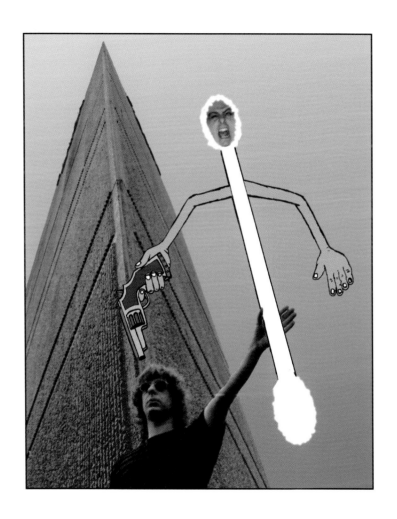

As a way of showing our sorrow, the Q-Tips foundation is offering a 10¢ discount to senior citizens who shop at Almy's. Limit one per customer. For more information regarding the kindness of this discount, see the "Discount Procedures Manual."

Discount Procedures Manual

There is a $240 processing fee with each discount granted. To save you the trouble, Q-Tips, Incorporated, has decided to simply bill all senior citizens $239.90. That way all senior citizens automatically get the discount—no fees or charges. For even more information about this offer, send three thousand dollars cash to Q-Tips, Inc., 101 Boulevard Road, Oregon, Mississippi. Include a stamped, self-addressed envelope and an extra one thousand five hundred dollars.

Notice

Due to a recent reputation crisis, the Q-Tips Corporation needs your support. Rush $1,700 cash to Q-Tips, Inc. Sales have been down almost 1 percent and they may continue to be 1 percent lower if you don't quickly rush your $1,700 cash.

This Just In

The Q-Tips Foundation has been attacked by several hundred dangerous Q-Tip monsters. We need your help in dealing with this crisis. Rush $1,700 cash to Q-Tips, Inc. Please hurry, we are waiting.

Special Notice

The executives at Q-Tips, Inc., when buying things like shoes, have discovered that they too have to pay a sales tax. Because of this, we request that those who have bought Q-Tips in the past mail $1,700 cash to Q-Tips, Inc., to make up for what we would have charged had we known this.

SUPERCHUNK

SHEMPY LEANED OVER so that he had a better view of his own hand.

"Iw, you got throw-up on my hand!"

"Gross—you're right. I guess I still had some throw-up on my arm and I touched your hand. I'll go get a towel or something." Hongo felt bad about the whole mess. "Oh my god—look! There's still throw-up in that coffee mug. Have you been sipping that?"

"Oh god Hongo, I can't believe this. Get me a new mug, would you? Wait...smile for a second...Iw! You've got a huge chunk of throw-up between your front teeth!"

"Iw! Where?" He started picking at it.

"No, it's still there."

"Did I get it?"

"No, it's still there."

"How 'bout now?"

"Ah...no, it's still there."

"Is it right here?"

"Ah, yeah, maybe you should look in the mirror." The

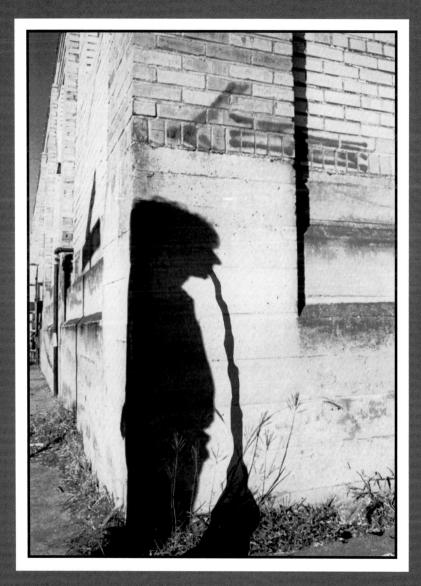

odor made Shempy feel like he might have to upchunk.

"Hongo, I can't believe this. This whole house is filled with pools of throw-up."

"Did I get it now?"

"No, still there."

"Now?"

"Still there."

"Now?"

"No."

BACK SCIENCE

A T FIRST "BACK SCIENCE" was just a guy (me). Then it became a concept, and then a fad, and finally it was a model, referred to by the heaviest of out-set thinkers. But back then Back Science was a walk to the swamp.

I was burly and fuzzy. Most of my hair had whitened. A walk meant sweating, and I could feel my brow redden. It was a relaxed sweat. At the end of the trail I searched out a perch right at water's edge. I had two notebooks, one to record movement, and one to list all examples of stagnation in view. But it didn't matter which notebook I selected from my over-all pocket on any given day. This was a science of acceptance. Leaning on one shoulder, I would sigh as sun caressed my cheek. I might look over at mid-swamp and notice an otter or a loon and record a few gentle words about habitation, repro-duction, etc., but only in the language of movement and still-ness. It didn't matter. If this information would be useful to the scientific community, or if I burnt my notebook for kindling, it didn't matter.

"Oh, the loon has moved. It glides along-top the green muck."

Back Science was a comfortable science; no timeline, no control groups. Just pleasant, airy info.

"A bee is by the loon. It pauses afloat."

The unaskable question, of course, is why did Back Science take off? How did it go from silent whisper words to a fiercely revolutionary model, which inevitably threatened and thus overturned what was once quantum mechanics?

I think the shift point, if there was one, would have been the day that I noticed I wasn't alone in the misty swamp. I peered over, almost at the edge of the sunken brush, and there was Officer Unilu. And after noticing him, it occurred to me that he had been there the whole time. I just thought he was a beaver dam! He didn't say anything when we made eye contact, he just tipped his blue police hat.

I'd have to admit that during the next few consecutive days, I felt a little awkward lying there with Unilu watching me. Really, he was only ten or so yards away. But I went on with my business as usual, and tried to relax like before. It was weird to relax with Unilu watching. We never spoke.

Anyway, my tender info made it from Unilu (and I don't know how this happened) to the scientific community at large. In universities I had never heard of, graduate pioneers were deconstructing my methodology. And, again with me

unbeknownst, science that had been began to evaporate. The uncertainty principle: gone. Relativity: no longer relevant. So thanx to a small-town cop named Unilu, Back Science took over as our basic model. I still sat in the yellowish mud.

"The otter has rolled onward."

And children overseas were studying Back Science and it was easy for them to learn because it made so much sense. Even some kindergartners were being introduced to Back Science. What really gets me now is that Timothy Shake, who thought he had redone the "mass equation," and who shook up the world with his low-temperature work, was baffled. They found him in his Swiss mountain cabin–lab squawking like a duck at his bent-moon poster.

Anyway, here I am. It's another sunny day. I got a little mud on me. I see an animal, oh, it's an otter. Looks like it's just sitting, cupped-mouth. There's Officer Unilu; he's still here—doesn't say anything. My pen is a little on the fritz, but I'm relaxed anyway. A few days ago the pen actually burst its ink. I almost was ready to ask Unilu if he had one. But his blue uniform looked so peaceful in the green muck over there, I didn't want to talk to him. So I didn't write for two days, I just watched. And that's about it. That's Back Science. I think from this tale, you can probably understand how some basic

formulae can go a long way. Mathematics is probably the key here, but I wouldn't touch the stuff. I don't need that key. All I need is an otter, and some numbers and equations, and in some ways I even need Unilu. There's a critter in the distance—oh, it's a loon. I think I'll watch now.

BOAST

MA PIERSON CAME HOME with a new jar of pickles. She put down that jar and scraped her faded, pink counter. Doing this eased some nerves, she thought.

"Oh what the fart, I'll call my son." Dial; ring.

"Hello?"

"Bibsy, it's Ma Pierson."

"Hi, Ma."

"Bibsy, I'm a callin' to tell you somethin' I gone done."

"Sure, Ma Pierson, go on, now."

"To others, I boasted of you."

Part II

And thus ended a wonderful thing. A mother told her son that she had, to others, boasted of him. That very mother called Anty Cranberry Pierson.

"Ma," said Anty Cranberry Pierson, "tell me, what have you ever done for Bibsy?"

"Well, there is one thing I done."

"What did you do, Ma? Tell me."
"To others, I boasted of him."

Part III
Bibsy called. Ma Pierson
slid a pickle down her thick
throat. It went down without
chewing or swallowing, but it
was delicious all
the same.

"Ma, I figured out why, to others, you boasted of me."

"Do you see now that it's the king reason?"

"Yes, Ma Pierson, it's because you know that my friend is a king."

"That's right, I know your friend is a king."

"But I want you to know that he's not king of too much. Really, Ma, he's just a little boy of seven who happens to be a king."

"I guess I'll not boast, then."

"To others, don't boast."

"I hear call-waiting, bye." Click.

"Ma Pierson, it's Anty Cranberry Pierson."

"Hello, Anty."

"Do me a favor, just say something identifiable."

"The quick quarry hound is here."

"Good; thanx."

Part IV

Ma Pierson sat her thunderous buttocks on the pink counter and dialed Bibsy, her son. She was munching on a spherical pickle.

"Hello?"

"Yeah, it's Ma Pierson. I was just talkin' with Anty Cranberry, and that made me think of some things I thought I'd tell ya."

"I'm certain it be fine if you done tell me those things."

"First, I think you should put all yer money in an IRA, ya hear?"

"I'm hearin' ya."

"Second, it's customary, sometimes to make a toast. Third, you know those white splotches on your car that come from birds? Well, from now on you can call them 'shooties.'"

"Is that all, Ma Pierson? 'Cause I got a burger in the oven."

"I want you to know one more thing."

"What?"

"To others, I boasted of you."

Trapezoidal Projectiles

O NCE THERE WAS A BOY who enjoyed, among other things, "trapezoidal projectiles." We could call him Ned (but we won't). The boy, nine, drove his go-cart along the sidewalk to a store which would provide parts for "trapezoidal projectiles." Along the sidewalk he saw condoilery trees with their thick, budding, green leaves. He also saw a variety of shrubs: qualerin, lamarost, and the pungent, yellow cooley bush. The aroma nearly flattened our go-cart boy.

The boy, Ed, parked by the front door of his favourite shoppe and went inside.

"Ed, nine, how are ya?"

"Oh, I'm good, Mr. Weekee, where's the scrap iron?"

"Oh, over there by the 'Antique Paint.'" Ed did find the iron, but "Antique Paint," he thought. "I could probably use some." The idea of 200-year-old brick-red paint just tantalized the boy. Now his "trapezoidal projectiles" would look like works by Rembrandt, Cooley, or De-l'Arte. So he pulled two weeks' allowance out of his shorts and paid Weekee.

On the way home Ed rode his go-cart by the river. This

141

time he saw snake-mint, limowa flowers, just in bloom, and pads of weekee-lily. Dardle trees gave off the aroma of tinted pine or whipper-snap bite. Ed thought, "Why does every god-damn speck of nature have to be described, everywhere I go?"

At home, the go-cart was parked near the doghouse and Ed was just buzzing with excitement, carrying his bag from the store and imagining "trapezoidal projectiles." The dog, "Weekee," was a terrier and he yelped all the way to the front door. He, too, loved "trapezoidal projectiles." Inside, it turns out that Ed's mother had just returned from "The Greenhouse

Store." She bought planters of Lockawok, Trolleyhok, and Pidalaponk; savory herbs like green larta and musty merch. The kitchen counters were lined with dirty clumps of tangy telit root, willor-wump, and killer stump.

Ed's room was a mess. The smell of welding tools and Antique Paint would soon sicken the family, except Weekee, the dog; as I said, he loved "trapezoidal projectiles," and he knew what was in store. Only a while later, Ed could be seen dragging that crazy contraption up the attic hatch. That attic sat proudly among the tops of the hemlocks. You could see the whole valley from up there: the green tops of screamish trees, larkosha thistle, and lomeo pines; fields of green wumsha, green tookoo, and green vegetables growing, like the green radish of Sunnylite-Field-Acres and the green Christmas radishes of Mount Toller, and of course green wee-kee trees and acres of bright, sunny green lichietta shrubs, flourishing beside orchards of green wenlort and green pensmort and green koala bears running amidst green grasses, such as the green wobodo weed and green tea, the green kishel-grass, and green ottop, green oto, green poto, green woto, green topoto, green topozoidal, green rectile, green trapezo, green wapacoidal, green weekee, green pozo, green wozo, green kozo, green zozo, and also some red zozo.

SUITE #102

"**Y**OU'RE A BASTARD," exclaimed Mrs. Filliminasnot-hedron-tetrahedron.

"Oh, so now I'm the bastard?" said the boss. His swivel chair creaked; his name was Donald Swivelchaircreak.

He touched his smooth mahogany pen. "You, Mrs. Filliminasnot-hedron-tetrahedron, are the bastard."

"Well, I guess we're all bastards," she snifeled.

"Yes, Mrs. Filliminasnot-hedron-tetrahedron, we are bastards."

The two bastards sat unpleasantly in their chairs waiting to see who would break the awkward silence.

It was Mr. Swivelchaircreak. He said, "This doesn't seem to be going anywhere."

They snifeled.

They were bastards. All two of them. Suddenly, Swivelfart dove out of his chair and jumped through his plateglass window. It wasn't suicide, since he knew about the huge awnings that had been installed—big, comfortable, blue and green awnings. He fell through them slowly. They were his

puff-clouds, his sunny summer saviors. He was swaying his arms. In slow motion he whispered love notes to the birds while falling, awning after awning, rolling spinning spawning. He fell through awnings, and flapping he floated fluffily in the awnings yawning. His satin awnings felt so good. Slowly in the breeze the Senator, Mr. Creakwheel, swiveled in his awnings, rolling and carelessly stumbling, swaying and pivoting and rolling in the yawnings. Light blue sky and mellow yellow sun—oops, there it is in my eye. Sunshine in my eye and I'm rolling in awnings. Sway roll roll sway awning makes me feel gay. Gay in awnings is all I feel. The sky is blue. The awnings are you. I'm very soft like a baby, and awnings are my satin this afternoon, falling and falling in the sky. To the sky with awnings hanging behind. Just awnings behind. Swaying. Mrs. Filliminasnot-hedron-tetrahedron also climbed in between the broken jagged glass and with only a small nicking of the hand with shiny broken glass edge, she floated into awnings. Blood now, and the hedron dame, and awnings. Blood and the Senator Creakwheel and that Mrs. bastard woman and a summer day. A slow slow slow summer day in the awnings. Rolling in the fabric. The fabric billowing back upward into the sky. Rolling back down in the breeze. Far, far in the sky, close, close back in the sway of falling into the

awnings. Immeasurable capacities unfolding into peaceful careless dissipation. Energy reaching entropy. The breeze has won. Ha Ha. The awning has won. Hear ye, awning. You won.

Part II

Later that afternoon Donald Swivelchaircreak had a dentist appointment. He was pumped for the appointment because he liked the waiting room ambiance. Really he had to use the lavatoire, and he knew that the dentist had a clean lavatoire.

Wrong again, swivelschmuck. There was green crud on the toilet seats, piss on the floor; someone had vomited in the sink. This was no blue-awning affair. A supposedly sterile environment was putrid.

Later, in the dentist's chair, Swivelfart noticed hairs wound up in the polisher unit. Someone else's spoodge was in the rinse bowl. The back molar X-ray cards had been pre-bitten. The bib had blood and pus from another. The hygienist started picking her nose with that pointy scraper. Problem is, that pointy thing scarred the inner-nose tissue. Blood came out and got on Swivler's lap. The hygienist went over by the window, squatted, and crapped.

Part III

That was enough for Swivelhead. He jumped out of his dentist's plateglass window. The comfortable, soft, silky, green, wonderful awnings were removed the day before for cleaning. "Ouch," he cried while splattering on the warm gentle pavement.

FINALLY, YOU MAY REALIZE while reading *Mike's Corner*, someone has written a book with no adverbs. How did I manage to pen the nineteen thousand six hundred and twenty-eight words and keep out those wretched modifiers? It started with the Phish newsletter, aptly titled *Döniac Schvice*, and the editorial help of Marni Davis, Shelley Culbertson, and Jason Colton. Thank you to them and to others who helped me re-edit and de-edit. I am feeling a sense of gratitude toward several who enhanced the book's visuocity with extra photos and illustrations: Richard D'Amato—page 91; Sofi Dilof—pages 54 (mammal part), 120, 127, 131, and 147 (nonmammal part); Andrew Fischbeck—page 88 (mammal part); Geoff Fosbrook—cover and page 142 (mammal parts); Thatcher Hayward—pages v and x; Chris Lindquist—page 97; and Danny Clinch—page 148. And I owe great debts of "yes, man" to Kristin Ellison and others at Bulfinch, to John Paluska and Burt Goldstein for managing my ass, and above all thanks to Cilla, who designed this book. She helped transform my childish prose into genuine eighteenth-century classical literature.

Mike Gordon

design and art direction by
PRISCILLA FOSTER